# Getting Started
# Drawing & Selling Cartoons

# GETTING STARTED

# Drawing & Selling Cartoons

## RANDY GLASBERGEN

NORTH LIGHT BOOKS

CINCINNATI, OHIO

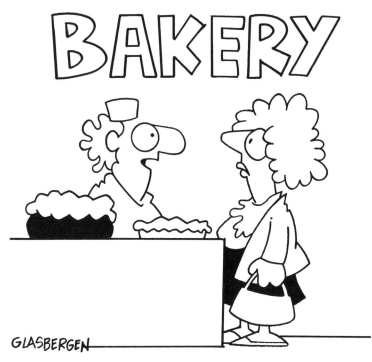

GLASBERGEN

*"What kind of German Chocolate Cake? East, West or Reunified?"*

97  96  95  94  93    5  4  3  2  1

Library of Congress Cataloging in Publication Data

Glasbergen, Randy.
    Getting started drawing & selling cartoons / by Randy Glasbergen. — 1st ed.
        p.      cm.
    Includes bibliographical references and index.
    ISBN 0-89134-471-3
    1. Cartooning — Technique. 2. Caricatures and cartoons — United States — Marketing. I. Title. II. Title: Getting started drawing and selling cartoons.
NC1320.G58      1993
741.5 — dc20                                                                    92-39755
                                                                                    CIP

Edited by Greg Albert
Designed by Sandy Conopeotis
Cover illustration by Randy Glasbergen

The permissions on page 115 constitute an extension of this copyright page.

**R**andy Glasbergen spent his childhood drawing on everything in sight and at age fifteen sold his first cartoon to a national magazine for five dollars. While still in high school, he illustrated his first children's book and sold hundreds of cartoons to major publications such as *Saturday Review*, *Changing Times*, *Boys Life*, *New Woman* and *Better Homes and Gardens*. After a year of journalism studies, Randy left college to freelance full-time. Since 1972 Randy has sold more than 15,000 cartoons.

Today Randy Glasbergen's cartoons appear regularly in *Good Housekeeping*, *Wall Street Journal*, *National Enquirer*, *Woman's World*, *Saturday Evening Post* and many other magazines in more than twenty-five countries.

His work as a cartoonist has also brought him a steady flow of humorous illustration assignments for a long list of clients, including Hallmark Cards, Scholastic Publications, Reader's Digest and Gibson Greetings. His humorous illustrations have been used in advertising, magazines, calendars, posters, newspapers, books and even on dog raincoats!

Since 1982 Randy has been the artist and writer for "The Better Half" cartoon panel, which is syndicated worldwide by King Features Syndicate and seen by millions of readers every day.

In addition to cartooning, Randy has also been a very prolific and successful author of greeting card humor. He has served on the Humor Writing Staff at Hallmark Cards in Kansas City and has been a freelance writer for several card companies, including Paramount Cards, Gibson Greetings, Oatmeal Studios, Paper Moon Graphics and TLC Greetings. Randy's ideas have been used in cards, mugs, note pads, T-shirts and gift items.

Randy Glasbergen lives with his wife and four children in a small town in rural New York. In his spare time he wonders what it would be like to have more spare time.

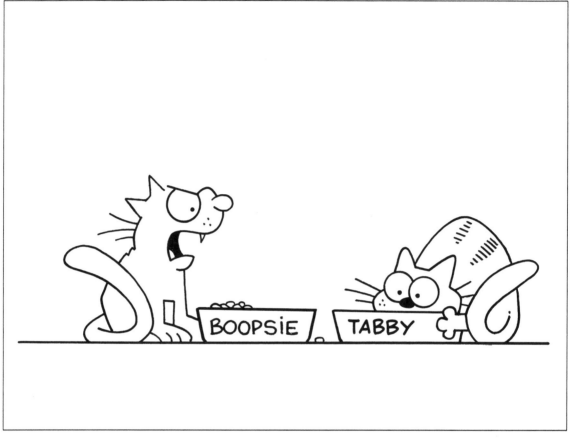

*"I* hate *the name Boopsie! Nobody takes you seriously if your name is Boopsie!"*

# ACKNOWLEDGMENTS

**T**hank you to all the cartoonists who generously contributed their time, cartoons and deepest secrets to this book: Marty Bucella, Tom Cheney, Bruce Cochran, Bob Vojtko, Bob Zahn, Martha Campbell, Revilo, John Caldwell and Joe Kohl.

Thank you to Johnny Hart for the "Think Funny" drawing he created especially for this project.

An extra tablespoon of gratitude to John Caldwell who got me into this thing in the first place.

Thanks Mom and Dad for the drawing board, encouragement, stamps, supplies and stuff from way back when.

I'd thank my wife for putting up with me while I worked overtime on this project, but I think she was glad to have me out of her hair anyway.

Also, thanks to Greg Albert and all the other folks at North Light Books for making something organized and finished out of my piles of paper.

*Todd's antiperspirant keeps him very, very dry.*

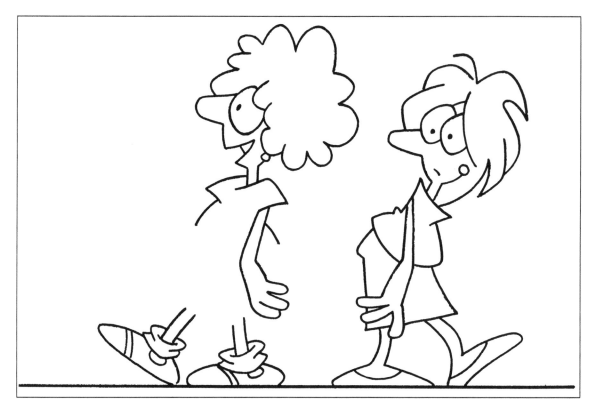

*With sensible eating and lots of aerobics, Patty's hips gradually disappeared.*

# TABLE OF CONTENTS

# 1 How to Draw Funny Cartoon Characters

The first step toward becoming a cartoonist is to learn how to draw funny cartoon characters. You can draw a character that is outrageous like Popeye, with his wildly exaggerated forearms, legs and jaw, or a simple, whimsical character like Charlie Brown who's drawn with very few lines. Every feature you draw adds to the character of your personality.

Your characters should be fun to look at and need to attract a reader's eye to your cartoon. A funny character is an attention grabber. The more visually interesting you make your character, the more the reader will be interested in your cartoon and read it.

As you learn to draw cartoons, try to create new and exciting characters that are fresh and inventive and fun to look at. Make your characters stand out from the rest of the herd. Whether you are drawing for family and friends or for millions of readers worldwide, you want your characters to attract attention because they are special, fun, exciting and interesting.

In this first chapter you'll learn how to draw funny characters step by step, quickly and easily. Your first step will be to learn how to draw a basic cartoon face using a variety of shapes and sizes, and then give these faces life through emotions and expressions.

Further in the chapter you'll discover how to add bodies and clothes to the basic head to create fun and interesting cartoon characters. The simple step-by-step shortcut on page 18 will show how easy it is to draw funny characters that show real-life actions. Hands also express mood and emotion so you'll see how to draw expressive hands and add them to your cartoon figures.

As you read this chapter, keep a pencil and paper nearby. Better still, keep lots of pencils and lots of paper nearby! While you're reading each page, take time to try out what you are learning. You'll learn a lot by reading, but you'll learn much more by doing. Throughout the chapter, special drawing lessons will guide you in practicing cartooning more effectively.

## Drawing the Basic Cartoon Head and Face

You first need to learn how to draw good, expressive cartoon heads and faces. In most cases, the face is the most important ingredient in any cartoon because it tells the reader who is speaking to whom, and it indicates a character's emotions. The face shows whether your character is woman, man, child, animal, old, young, attractive or goofy-looking. Although hands, bodies and scenery are also important, the face usually communicates more to the reader than any other aspect of your cartoon drawing.

Think of your cartoon character as an actor. Just as an actor must be a master of many emotions, a good cartoonist must be able to understand many different emotions and communicate them through his cartoon character's face.

To get started drawing cartoon faces, practice the step-by-step demonstrations here and on the following pages. Practice until you are comfortable with this simple technique then try a few faces of your own. Just get out a pencil and be playful. For now, don't worry about inking your drawing or being perfect. Just get the hang of it and have some fun.

### Straight-on View

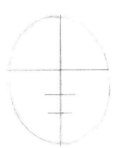

**❶** Start by drawing a simple circle or oval for the head.

**❷** The vertical center line helps you find the middle of the face. Draw the line that positions the eyes a little less than halfway down the head. Place the nose and mouth lines at equal distance between the eye line and the chin.

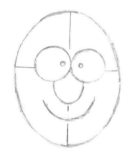

**❸** Position the eyes, nose and mouth on the guidelines. One difference between a normal face and a funny one is exaggeration. See how by placing the eyes close to the vertical center line you make this guy look goofy.

**❹** Finally, add some details — hair, ears, eyebrows and anything else — that give your character a unique look.

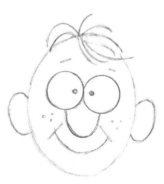

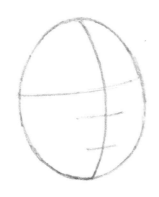

## ¾ **View**

❶ Draw a basic oval head and add guidelines where the eyes, nose and mouth go. A curved center line lets you draw a character who is looking off to the side.

❷ Position the eyes, nose and mouth off-center following the curved guidelines. Notice that the nose intersects the cheek line.

❸ Finish the face with hair. As you practice drawing this face, add various finishing touches to create different-looking characters. By adding longer hair this character becomes a young girl.

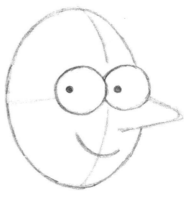

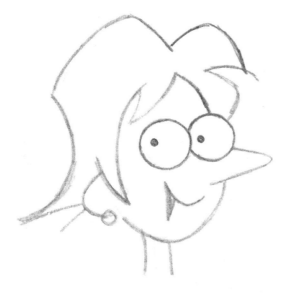

## Profile View

**❶** Start with the basic oval and sketch in the facial guidelines as you did for the straight-on and ¾ views. The front of the circle functions as the center line.

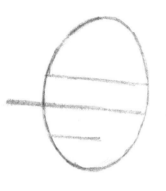

**❷** Draw the facial features, positioning the eyes near the edge of the oval and the nose directly on the side. Try drawing noses of differing sizes and shapes. Notice the proportions of the features on this face. Everything — the eyes, ears, mouth and particularly the nose — are larger than normal, giving this guy his own unique look. An open mouth is actively expressive.

**❸** Add details to make your character male, female, young or old. With the profile you can show more of the neck and collar, and so, more body action.

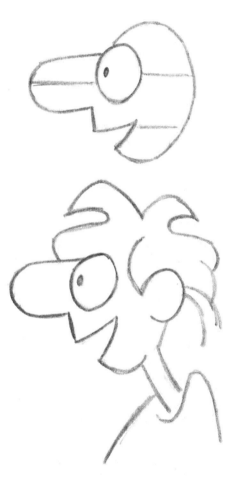

## Using Different Head Shapes

To understand how much the head shape adds to a cartoon character, instead of using a circle or an oval, draw a cartoon head and face using a rectangle, square, triangle or pear as your basic shape. The illustrations on these two pages show just a few of the characters you can draw using these four shapes.

Different shapes create different effects. A rectangularly shaped face can make your character look tall and thin while a square face can create a heavier and stronger look.

Look through some magazines and see if you can figure out what shapes people's heads are. For example, former President Richard Nixon has a pear-shaped head, while the late Fred Astaire had a head shaped like an upside-down pear, with the wide part at the top and the thin part at the bottom. To draw George Washington you would start with a square, but to draw Abe Lincoln you would need a long, thin rectangle.

Have some fun and experiment with a variety of different head shapes.

**Oval**

An oval lets you create the widest variety of characters.

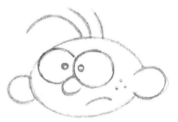

You can draw a little boy . . .

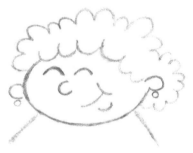

or a chubby grandma . . .

or a stuffy banker type.

## Square

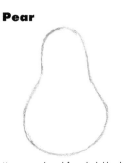

The lines of a rectangle show strength.

Rectangles are great for drawing a superhero . . .

a stern school teacher . . .

or a soap opera hunk.

## Pear

Many pear-shaped faces look like they need a trip to the gym!

Former President Richard Nixon was a favorite subject of political cartoonists. His pear-shaped face is fun and easy to draw.

Haven't you seen this pear-shaped woman in the supermarket?

Most pear-shaped faces have a soft, full-jowled appearance.

## Triangle

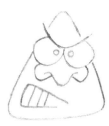

A triangle gives you more unique-looking characters.

With a triangle you can draw a narrow-minded man with a big jaw . . .

a little girl with big hair . . .

or a man with a king-sized nose.

# How to Draw Expressive Faces

Once you've learned how to draw a basic cartoon head and face, you need to make them expressive. Without expressions your characters are emotionless mannequins.

The best way to learn about facial expressions and emotions is to study your own face in a mirror. Go get a mirror right now. (C'mon. Go get the mirror! Do you want to learn this stuff or what?) Now look at your face in the mirror and smile. What happens to your mouth when you smile? What happens to your eyes? Do your eyes get big or squinty? What happens to your eyebrows when you smile?

What happens to your face when you act angry? What happens to your eyebrows, do they go up or down? Does anything happen to your nose? Your mouth or teeth?

Whatever happens to your face should happen to your cartoon character's face. If you look angry and your eyebrows are low, your character's eyebrows should be low. If you look surprised and your mouth gapes open, the same thing should happen to the mouth in your drawing.

The illustrations on this and the next five pages show thirty-two examples of expressive cartoon faces. For more examples, study the cartoons you see in newspapers and magazines and don't be afraid to imitate what you see.

Practice a wide variety of different expressions. The more you practice, the easier it becomes. Eventually you'll know how to draw a particular face without going to a mirror and making a bunch of strange faces and feeling like a fool!

**Happy** = huge eyes and a wide smile

**Mellow** = eyes at half-mast and a wavy mouth line

**Angry** = brow and mouth lines curve in opposite directions

**Very angry** = lots of teeth, bulbous nose and furrowed brow line

**Sad** = brow lines meet at the center line, mouth line is very small and curves downward

**Surprised** = slightly off-balanced head shape, mouth drawn open

**Exhausted** = half-closed eyes, drooping mouth, tongue hanging out

**Enthusiastic** = wide eyes, mouth smiling and open, even the ears are upturned and perky

**Shy** = closed eyes and a calm mouth line

**Frightened** = wide-open and curving mouth, gigantic eyes and a spikey hairstyle

**Sleepy** = closed eyes, ten o'clock shadow and mussed hair

**Laughing** = closed eyes and a huge, geometric-shaped mouth

**Bored** = half-mast eyes and a straight-line mouth

**Content** = smiling eyes and mouth, even nose is curved into a slight smile. All features are calm and moderate, not bold.

**Worried** = sloping brow, drooping mouth and eyes, lifeless hair

**Devious** = Jack Nicholson eyebrows, pointy nose and sinister-looking half-mast eyes

# Drawing Lesson #1

❶ Draw a circle, an oval, a square, a triangle and a pear shape. Make a basic cartoon face from each of these shapes.

❷ Write a list of as many human emotions as you can think of: sad, happy, depressed, excited, grumpy, etc. Draw a cartoon face for each of these moods using different head shapes. Remember to act out each emotion in a mirror. Don't try to guess what an emotion looks like; use a mirror and find out. If anyone asks what you're doing, tell them it's a trendy new workout program called facial aerobics!

❸ Draw and draw and draw and draw some more. If learning to draw cartoons is important to you, set aside at least thirty minutes every day to practice. Like any skill, you have to master the basics and practice them over and over and over. You can't play baseball once and then expect to get a job in the big leagues. The same rule applies to cartooning!

# More Expressive Faces . . .

Here is an oval-faced, *uncertain* boy.

Big eyes are a great way to show any extreme emotion.

A *happy*, excited face has large eyes, high eyebrows and a wide, open smile.

Does the ear shape add to expression? Try it yourself and find out!

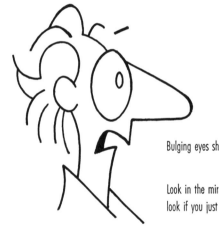

Bulging eyes show *shock* and terror.

Look in the mirror. How would *your* eyes look if you just got a $400 phone bill?

This man notices that something is about to fall on him . . . is it a leaf or an anvil? His eyes search upward for the answer and his mouth grimaces in *fear* of the unknown.

Half-closed eyes show *calmness* or *boredom*.

A small, open mouth shows that she's speaking calmly and softly.

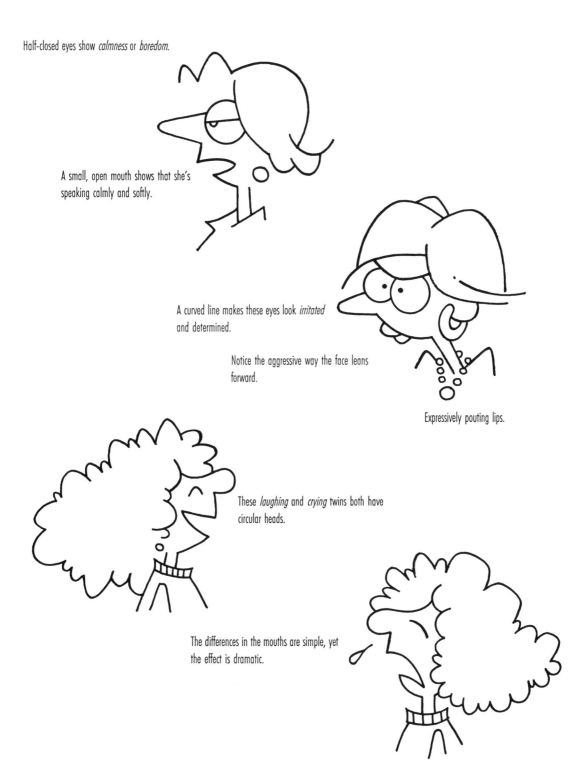

A curved line makes these eyes look *irritated* and determined.

Notice the aggressive way the face leans forward.

Expressively pouting lips.

These *laughing* and *crying* twins both have circular heads.

The differences in the mouths are simple, yet the effect is dramatic.

Details as simple as a tear add impact.

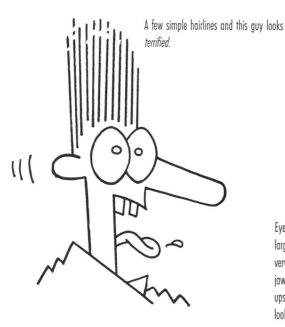

A few simple hairlines and this guy looks *terrified*.

Eyebrows with an exaggerated slant and large, upset eyes show that this woman is very worried about something. Her bulging jaw and frown add to the look of *worry* and upset. Messy, energetic hair completes that look.

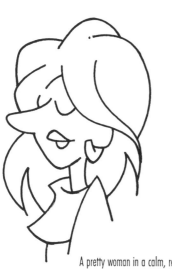

A pretty woman in a calm, restful mood. Her attractiveness is highlighted by delicate nose, chin, lips and soft curves.

Notice the position of the eyeballs. This man seems *friendly* because he's looking at you straight on.

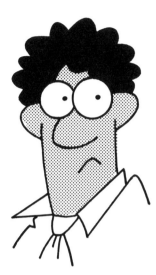

This woman probably just heard a great joke from a friend or co-worker. Her laughter has brought her smile up high and pushed her eyes closed tight. Her bouncing hair and outstretched neck help communicate the energy in laughter.

This man has just heard a loud noise in the next room. His questioning eyes look aside to find out what's going on, while his frowning mouth shows he expects the worst.

*Anger* is easy to show with two simple, straight lines for eyebrows.

This cartoon face has a long, rectangularly shaped head.

This man's anger is exaggerated by showing his teeth and a raging tongue.

Noses can be long or short, pointy or rounded. Try many different types when you practice.

## Drawing Cartoon Hands

When you draw a cartoon character, pay special attention to the hands. Hands can be nearly as expressive as faces and can tell a great deal about your cartoon character's mood and attitude.

The basic cartoon hand is made up of a simple circle with five "sausages" added to it as you can see in the demonstration below. Actually it's not uncommon to find only three fingers and a thumb on many cartoons hands. This is a tradition that goes back as far as the first Mickey Mouse cartoons and continues today.

Unless you're drawing a close-up, hand details are not very important in a cartoon. There's little need to worry about how many wrinkles are on the pinky of the left hand. Fingernails are another generally unnecessary detail unless you're doing a cartoon about a glamorous woman with a long set of claws.

And be aware of the differences be-tween male and female hands. A woman's hand should be drawn smaller and more slender than a man's.

Watch how people use their hands when they talk. They point their fingers to emphasize what they are saying, they throw their hands up in the air when they are exasperated, they clench their fists when angry, they bite their nails when nervous. Your cartoon characters will be far more interesting and expressive if you learn how to use hands effectively.

Study the step-by-step demonstration below and try a few hands of your own. Look at the cartoons you see in print or in animation. What do the hands look like in these drawings? Make a mental note of what you observe or put it in a sketchbook. Imitate what you see and try some innovation to create your own unique version of cartoon hands. The illustrations on the opposite page show how hands can express specific emotions or actions.

❶ Draw a circle with six straight lines of different lengths.

❷ Using the straight lines as guides, draw six sausages.

❸ Give some roundness to the palm, and you have a cartoon hand.

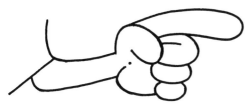

Point a finger . . . to accuse, to lecture, to indicate a direction, or just to point at an object.

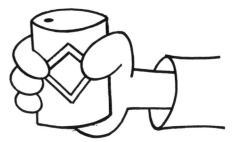

Fingers behind the can are unseen, appearing only as they wrap around the side. The thumb holds the front of the can tightly.

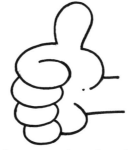

Thumbs up means everything is okay. It also means "I need a ride." Notice that the palm has shape and mass, too.

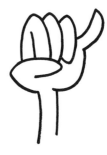

Female hands are usually smaller, more delicate and more graceful than male hands.

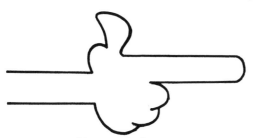

The straighter lines of this pointing hand show that the figure is more uptight than the figure above.

From most angles, one finger will slightly block your view of the finger next to it.

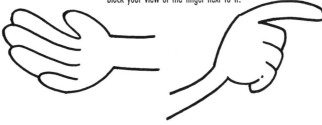

## Hands in Action

Although hands do not have eyes, eyebrows or a mouth, they do have expressions. Hands communicate much more than we often know. Hands can show happiness, tension, anger, nervousness, boredom, tiredness, curiosity and many other feelings.

To understand better how hands show emotion, pretend that you are an actor or actress on a stage. Act out the following minidramas and pay attention to how your hands communicate.

1.  You just got a letter from the IRS saying you owe an extra $4,500.
2.  You are holding a tiny, newborn baby and on her forehead is a small spider that you must remove.
3.  You are eating dinner in a restaurant and you are very, very nervous because this is the first date with someone you are very attracted to.
4.  You are getting dressed after an unusually long and exhausting workout in a very, very hot gym.

*Fearful* hand with rigid, open fingers shows that this man is *not* relaxed.

*Confused* hands ask "What's the problem, dear?"
Wide-spread fingers help express tension and energy.

*Excited* hands and arms seem to say "Don't worry, be happy!"

*Concerned* hands with a finger in or near the mouth show contemplation.
A hand on the hip is more natural than just having it dangle at her side.

## Drawing Lesson #2

Take out your sketchbook and fill a whole page with nothing but hands. Draw a(n):

- hand pointing
- hand holding a ball
- hand hitchhiking
- hand begging for money
- nervous hand
- angry hand
- hand scratching a head
- hand poking somebody in the stomach
- hand pushing a button.

Cartooning is a creative activity, so *be* creative and try to think up a whole page of both ordinary and outrageous hands.

Have fun with all of this! It's playtime! Let your imagination run wild.

*Angry* hands are eager to make a point.
A clenched fist shows determination.

*Bored* hands seem lifeless.
Notice how the palm follows the contours of her face.

# Drawing the Cartoon Figure

Unless you are drawing horror comics, your cartoon head should have a body attached to it. Drawing bodies is a bit more complicated than drawing faces because bodies have more moving parts to deal with.

Every body part tells something about your cartoon character. The posture tells whether the character is feeling energetic or depressed. The hands can express a concern, excitement or aggression. The legs and feet communicate action — running, standing, walking, kneeling, etc.

If you can draw a stick figure, you can begin to draw cartoon bodies. Think of the stick figure as the skeleton of your cartoon character. The stick figure is the foundation upon which you will draw your characters' bodies and clothes. The step-by-step demonstrations on these pages show an easy way to turn your stick figures into fun and expressive cartoon figures.

To understand how the body works, use a full-length mirror to study your own body in motion. When you walk, what are your arms doing? How about your legs?

When you are not drawing, study other people. When you see someone jogging, make a mental note of his movements, the position of his arms and legs, the look on his face, and his posture. When you see a mother in the supermarket with a difficult child, make a mental note of their actions and file them away in your brain for future reference. Study all kinds of people and try to create a mental photo album inside your head.

❶ Start with a simple stick figure.

❷ Begin to draw the face. Add guidelines for facial features like you learned in the step-by-step demonstration on page 3. Add hands with "spoke-like" fingers and simple clothes.

❸ Finish the face. Exaggerate the features somewhat to create the goofy expression. Flesh out the neck, arms and hands. Add detail to the clothes and shoes.

## Cartoon Figures in Action

Getting your cartoon characters into action will take a little practice, but will be much easier if you start with a basic stick figure every time. On this page, and on the next three, you'll see eight basic stick figures and the cartoon figures you can draw from them.

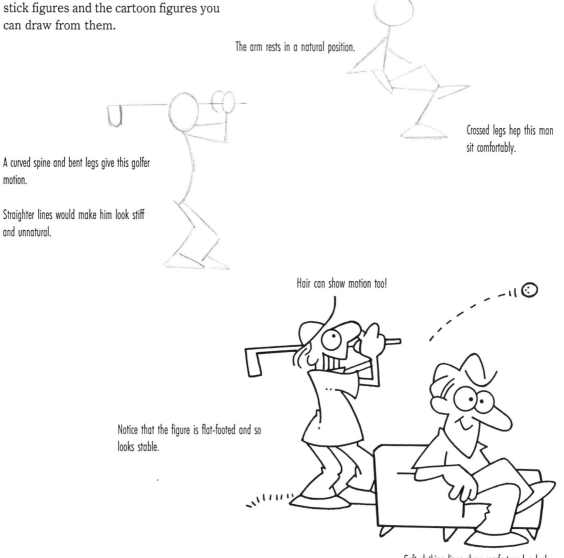

The arm rests in a natural position.

Crossed legs hep this man sit comfortably.

A curved spine and bent legs give this golfer motion.

Straighter lines would make him look stiff and unnatural.

Hair can show motion too!

Notice that the figure is flat-footed and so looks stable.

Soft clothing lines show comfort and a lack of tension.

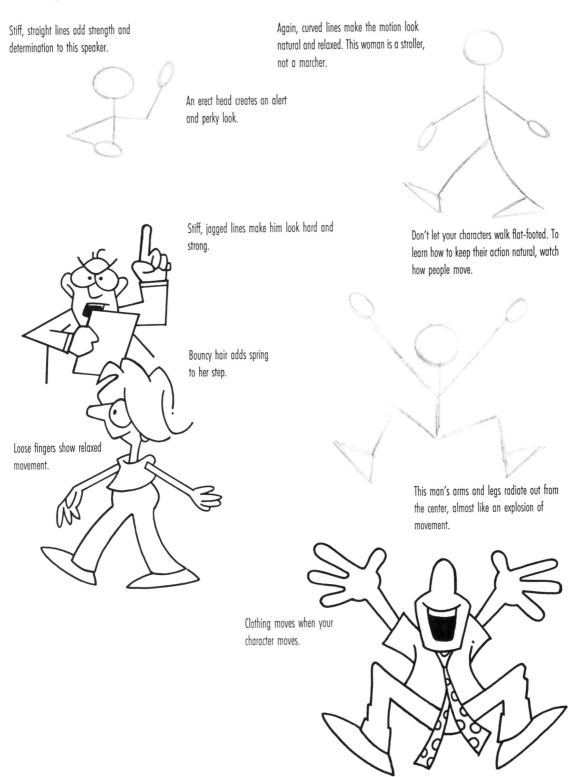

Stiff, straight lines add strength and determination to this speaker.

An erect head creates an alert and perky look.

Again, curved lines make the motion look natural and relaxed. This woman is a stroller, not a marcher.

Stiff, jagged lines make him look hard and strong.

Don't let your characters walk flat-footed. To learn how to keep their action natural, watch how people move.

Bouncy hair adds spring to her step.

Loose fingers show relaxed movement.

This man's arms and legs radiate out from the center, almost like an explosion of movement.

Clothing moves when your character moves.

Head tossed back, hands in the air . . . this guy just won the lottery.

Another example of how a curved spine and bent legs prevent a character from looking like a stiff mannequin.

## Drawing Lesson #3

❶ Draw a stick figure for each of the following poses: walking, sitting, running, kneeling and crawling.

Remember that *you* determine the way the cartoon head and face will look by the shapes you draw. This applies to the body, too. If you make the stick figure really tall or really squat your cartoon figure could look like Kareem Abdul Jabar or Alfred Hitchcock.

Add facial features, arms, legs, torso, hands, hair and clothes to make each stick figure a cartoon figure. Try using different facial features to give your cartoon figures different emotions like excitement, concern, fear or boredom.

❷ Now get a copy of *Sports Illustrated* magazine. It's full of action poses. Pick out five poses from the magazine and draw a stick figure version of each one. Then draw a cartoon version of each figure.

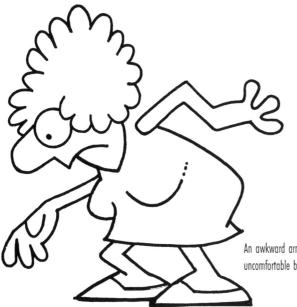

An awkward arm shows this woman is uncomfortable bending over.

Legs are spread apart to keep the figure balanced.

## Variety in Your Cartoon Characters

Cartoon characters come in all shapes, sizes, sexes, ages, ethnic groups and species. On the following pages you will see how to bring variety to your own characters. As you read, pay attention to what makes each type different from another. Take a closer look at the people you see every day. What makes your mother look different from your father? What makes your boss look different from the employee who just started last week? How can you tell an Arnold Schwarzenegger movie from a John Candy movie? How does Farmer Brown know that his chicken is not a cow?

Become more observant of the people and creatures around you. Become more aware of their differences and similarities and bring that information to your drawing table along with your pencils and paper.

### Tall and Short Cartoon Bodies

A *tall* person begins with a tall stick figure, made with long lines and a long, oval face.

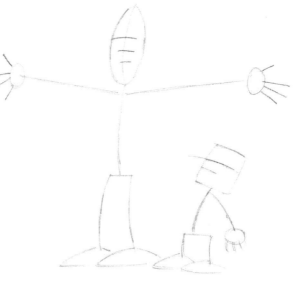

A *short* character begins with short lines and a round or square head.

Even his hair is tall!

The long, vertical moustache lines fit in well with the other long lines used to create this character.

A long nose adds to the stretched-out look of this man.

In a real person, these arms would nearly reach the floor . . . but this is a *cartoon* so feel free to exaggerate!

I ♡ BEING TALL

Everything about the short man is shorter . . . shorter arms, shorter nose, shorter neck, shorter legs. Fingers are shorter, too.

Baggy pants that are too long help point out how short this little guy is.

Long feet for tall guys with tall toes.

Think of the short character as a squashed version of the tall character.

## Thin Characters and Fat Characters

Tapered, pointy hair looks thinner than round, bouncy hair.

The thin nose is slimmer and pointier than the fuller fat nose.

Arms, neck and legs are more angular on a thin person.

Skinny spaghetti legs . . . don't give her tree trunk legs!

Rounded hairlines add to her full, curvy appearance.

Every part is rounder, softer and fuller on a fat person.

Even the feet are thicker. (Would small feet support this body?)

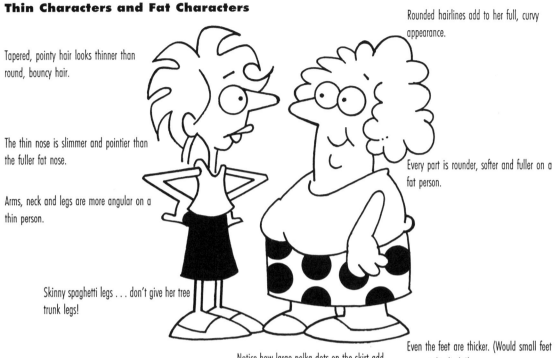

Notice how large polka dots on the skirt add to the overall round look of the character.

## A Young Person and an Old Person

Full head of hair.

Bright eyes and an alert face.

T-shirt and jeans are more apt to be worn by the young man.

Young people are generally more active and animated.

Shaky lines and a hunched-over back make this character look tired, weak and worn.

Balding. A few feeble hairs remain.

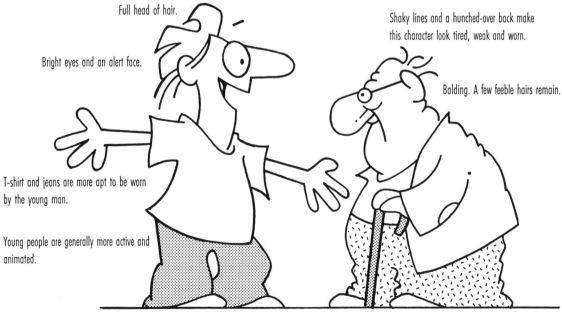

Pants hiked up high to cover potbelly.

A cane helps stereotype this person as an old man.

# Drawing Lesson #4

Draw a professional basketball player shooting the hoops in the driveway with his three-year-old daughter while his wife and infant son cheer them on. Remember what you learned earlier in this chapter about tall and short, young and old, male and female. Also remember what you learned about using stick figures to create action in your characters.

## The Muscular Body and the Weakling

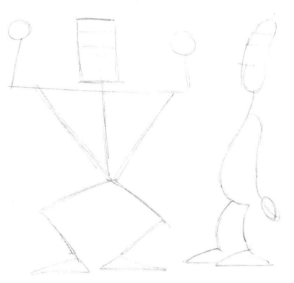

Here are the stick-figure foundations for the muscleman and the weakling. Compare the strong, angular lines of the bodybuilder to the limp, curvy lines of his 98-pound counterpart. A triangle was used in the muscleman's stick figure to help establish a dramatic muscular taper for his torso.

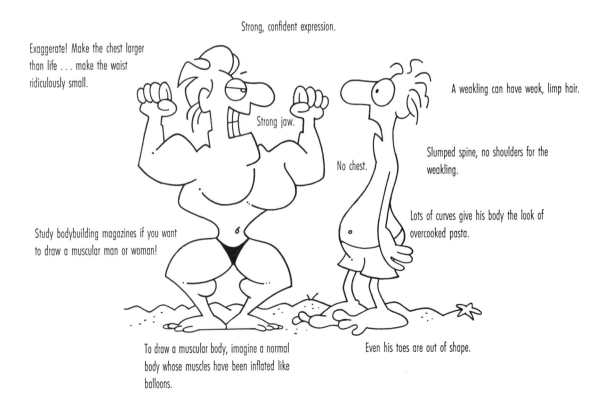

Strong, confident expression.

Exaggerate! Make the chest larger than life . . . make the waist ridiculously small.

Strong jaw.

Study bodybuilding magazines if you want to draw a muscular man or woman!

To draw a muscular body, imagine a normal body whose muscles have been inflated like balloons.

A weakling can have weak, limp hair.

No chest.

Slumped spine, no shoulders for the weakling.

Lots of curves give his body the look of overcooked pasta.

Even his toes are out of shape.

## A Woman and a Man

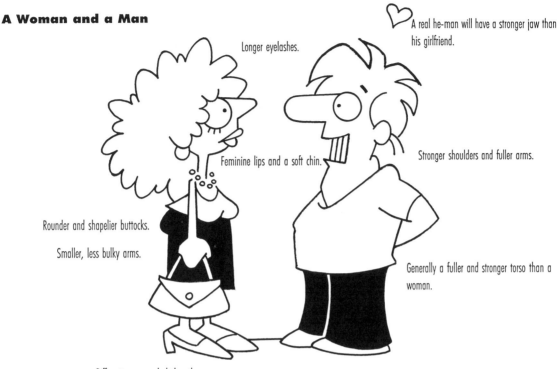

Longer eyelashes.

A real he-man will have a stronger jaw than his girlfriend.

Feminine lips and a soft chin.

Stronger shoulders and fuller arms.

Rounder and shapelier buttocks.

Smaller, less bulky arms.

Generally a fuller and stronger torso than a woman.

Different props and clothes than a man.

## Children

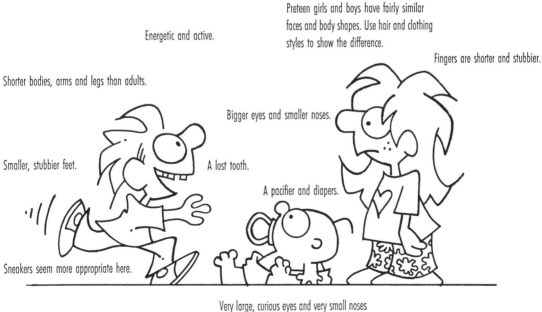

Energetic and active.

Preteen girls and boys have fairly similar faces and body shapes. Use hair and clothing styles to show the difference.

Fingers are shorter and stubbier.

Shorter bodies, arms and legs than adults.

Bigger eyes and smaller noses.

Smaller, stubbier feet.

A lost tooth.

A pacifier and diapers.

Sneakers seem more appropriate here.

Very large, curious eyes and very small noses and ears.

# Animals

Drawing cartoons animals is not as difficult as you might imagine. The basic steps for drawing animals are the same steps you used to draw people:

1. Make a stick figure skeleton for your character.
2. Remember to include layout lines for the facial features.
3. Flesh out the limbs and torso.
4. Add the rest of the details, hair, teeth, ears, etc.

The stick figures you'll draw for your animals will be different from your human stick figures and the details you add will be different. But remember to follow the four steps above and your animal cartoons will be much easier to draw.

There is an almost infinite variety of animals in the world and it's not always easy to remember what each and every animal looks like. Drawing animals is fairly easy; remembering what they look like is the hard part. When you draw animals, it is *very* important to keep some sort of illustrated reference book at hand. For example, if you want to draw a water buffalo and you're not sure exactly what one looks like, a well-illustrated book of animals can be a great problem solver. Buy yourself a book about zoo animals and keep it with your pens and pencils for reference.

Also become aware of how other cartoonists draw their cartoon animals. Learn from the masters and incorporate bits and pieces of their work into your drawings as you work to create and develop your own cartooning style.

## A Giraffe

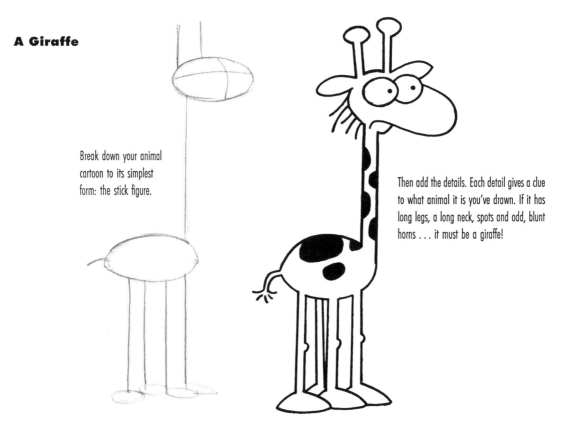

Break down your animal cartoon to its simplest form: the stick figure.

Then add the details. Each detail gives a clue to what animal it is you've drawn. If it has long legs, a long neck, spots and odd, blunt horns . . . it must be a giraffe!

## A Creepy Crawly Creature

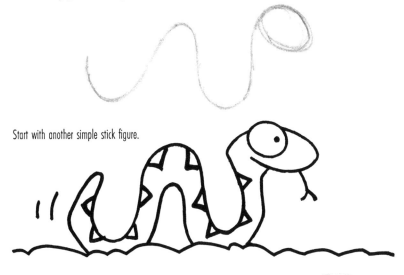

Start with another simple stick figure.

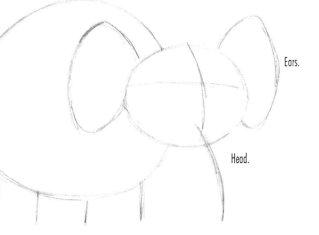

Add details. Spots on its back and a forked tongue make this a snake. How would you change this character if you wanted it to look like a worm? A caterpillar? A centipede? A belt?

## An Elephant

To draw an elephant or other large bulky creature, you may need to create a stick figure using more circles, squares or ovals. An elephant is easy to draw if you break down the head and body into four simple balloon shapes.

Torso.

Ears.

Head.

Sticks are okay to get you started with the trunk, legs and tail.

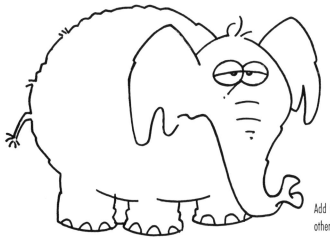

A cartoon should be simple . . . you can indicate wrinkles with a crinkled line or two.

Add wrinkles, a few hairs, big toenails and other elephant details.

## Household Critters

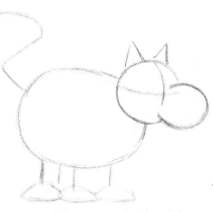

To draw a cat, start with sticks and balloons to get the basic shape.

Add cat details: pointy ears, small nose, whiskers, plump and furry body, paws.

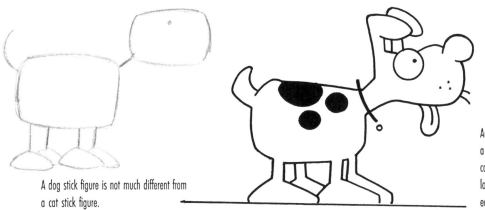

A dog stick figure is not much different from a cat stick figure.

Add dog details. What makes a dog look different from a cat? Body size, ear shape, longer neck, flappy tongue, eager attitude.

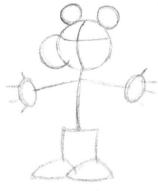

A rodent stick figure.

Is this a hamster? Or just a very small bear with bad teeth?

## A Cow

Always begin with a stick figure! This will make your drawing much easier. Never skip this important step! This stick figure could develop into a fat dog or a wolf or a rhino or a water buffalo . . . or a cow.

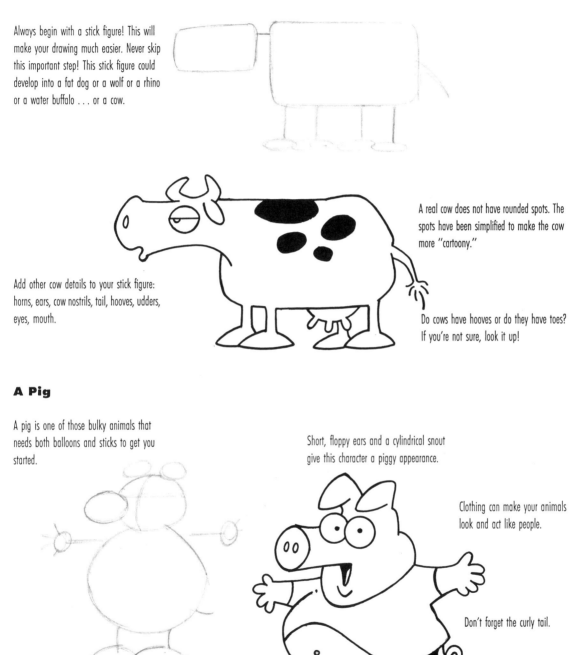

A real cow does not have rounded spots. The spots have been simplified to make the cow more "cartoony."

Add other cow details to your stick figure: horns, ears, cow nostrils, tail, hooves, udders, eyes, mouth.

Do cows have hooves or do they have toes? If you're not sure, look it up!

## A Pig

A pig is one of those bulky animals that needs both balloons and sticks to get you started.

Short, floppy ears and a cylindrical snout give this character a piggy appearance.

Clothing can make your animals look and act like people.

Don't forget the curly tail.

This is a cartoon, not real life . . . so you can put fingers on a pig if you want to . . . and a belly button, too.

## Birds

Birds are easy if you take time to determine their stick figures first. Use balloons for the head and body, sticks for the wings and legs.

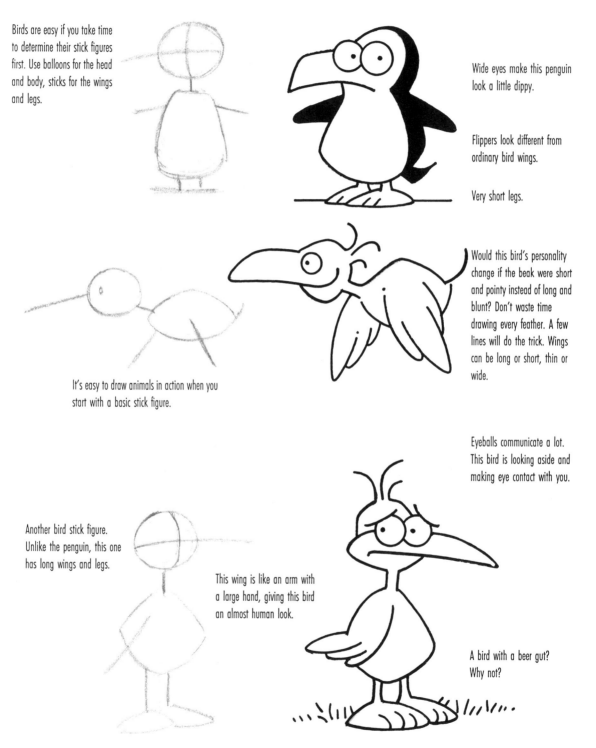

Wide eyes make this penguin look a little dippy.

Flippers look different from ordinary bird wings.

Very short legs.

It's easy to draw animals in action when you start with a basic stick figure.

Would this bird's personality change if the beak were short and pointy instead of long and blunt? Don't waste time drawing every feather. A few lines will do the trick. Wings can be long or short, thin or wide.

Eyeballs communicate a lot. This bird is looking aside and making eye contact with you.

Another bird stick figure. Unlike the penguin, this one has long wings and legs.

This wing is like an arm with a large hand, giving this bird an almost human look.

A bird with a beer gut? Why not?

## Alligator

An alligator stick figure is similar to a snake stick figure, but with legs and a larger head.

## Drawing Lesson #5

Go to a bookstore or library and get yourself a book that's loaded with animal photographs or realistic illustrations of animals. Use it to help you draw each of the following animals: kangaroo, ostrich, beaver, flamingo, lion, chimpanzee, water buffalo.

Four simple details make this alligator look fierce: low eyebrows, flared nostril, frown, and sharp teeth.

Scales can be indicated with just a few simple lines.

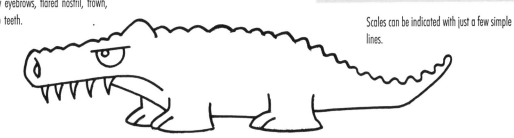

## Tortoise

Start with an oval, a half-circle and five sticks for the legs and tail.

Half-closed eyes help make this tortoise look slow and dull.

A reference book was used here to research the markings of a tortoise's shell.'

Don't forget to add a small tail.

## How to Give Your Characters Personality and Identity

If all cartoon characters looked alike, they would be very boring. If all cartoon characters looked alike, it would be quite confusing. If everyone looked the same, how could you tell the difference between a banker and a beach bum? Every good character should have interesting details that give you clues to his or her identity. For example, Frankenstein and The Wolfman are both "monsters," but it's the details that make them very different kinds of monsters. Groucho and Harpo were both Marx Brothers, but the thick, fake moustache, cigar and glasses made Groucho a very different personality than is brother Harpo who wore a curly blonde wig, crushed top hat, and oversized trench coat. Similarly, the clothes and hair of a school gym teacher on the job are going to be quite different from the clothes and hair of a fashion model on the job. What can you do to give your cartoon characters personality and identity? When you sit down to draw any character, ask yourself the following questions:

An average businessman.

Bizarre hair and an oversized bow tie turn the "average businessman" into a nerd.

Change the hair, add an unkempt moustache: an eccentric college professor or a bartender.

Here is Joe Normal.

Change a few details and "Joe Normal" becomes an early twentieth-century immigrant.

"Joe Normal" throws away his coat and tie, lets his hair grow long and joins a heavy metal band.

Typical Jane on her way to the office.

Typical Jane on her way to the library.

Typical Jane as a teenager on her way to a baby-sitting job.

- *Who* am I drawing?
- *What* does this person do?
- *How* is this person special or different?
- *Where* does this person work or spend his or her time?
- *Why* is it important to make this person look a certain way?

The following pages give examples of how you can turn an average cartoon character into a more unique or defined personality with just a few easy details.

Before moving on to the next chapter, take a few minutes to review what you've learned in Chapter One. Continue practicing what you've learned so far. If you want to improve, try to set aside at least thirty minutes everyday to work on your cartoon drawings. Like any skill, you must practice your cartooning a lot if you want to become good at it . . . and then do it some more . . . draw, draw, draw, draw and draw some more! Fortunately, cartooning is so much fun you'll find yourself wanting to do it all the time and your practice time will feel more like playtime!

A boy headed for football practice.

Change shirt and hair and you have a boy headed for skateboard practice.

A few more changes and you've got a boy headed for trouble.

Notice how a few simple changes transform this dog from "Barney" . . .

. . . to "Jake" . . .

. . . to Fifi.

Turn this one into Mary the millionaire.

On a sheet of tracing paper, take a pencil and change her to Mary the NASA technician.

Here's sweet Mary, everybody's friend.

The characters in this office gang all have distinctive features that make each one a unique personality: clothing, physical condition, facial appearances, props, height, posture, grooming, etc.

A look of intensity and determination plus a neat, well-fitting suit give this man the look of an ambitious young executive.

This woman's pregnancy gives her life an element not found in the other characters.

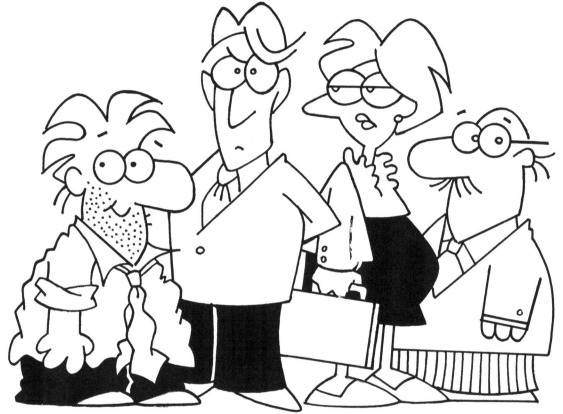

An unshaven, wrinkled appearance make this guy stand out as the office slob.

This man's figure, glasses and balding head indicate that he is older and more experienced than his younger co-workers.

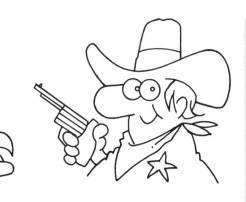

You instantly know this man is a cowboy from his western hat, bandanna and six-shooter.

A stethoscope and long lab coat on this woman quickly identify her as a doctor.

You can tell this dude is part of a heavy metal rock band. (How would his appearance change if he switched to Country & Western music?)

These are the cap, coveralls and rake of a farmer, not an advertising executive.

## Drawing Lesson #6

❶ Draw an ordinary-looking man. Next, redraw the same man as each of the following:

- a corrupt politician
- a wizard
- a very powerful king
- a football player
- an energetic disk jockey
- the guy who cleans up after the elephants at the zoo

Remember to use a variety of details to achieve the personality and look you're trying to achieve. Use props, clothing, facial expressions, different body types, posture, body language, grooming, etc. Each detail is a clue to the identity of your character.

❷ Draw six members of a high school teaching staff. Include both men and women and make each staff member unique. Include details and props that tell something about each person. (For example, which teacher is mean, which one is lazy, which one is a health fanatic, which one is romantic, which one is on a diet, which one is tired, which one is especially intelligent, which one is stressed-out, etc.)

❸ Bring your drawings from the previous two exercises to a friend or family member. Ask them if they can identify the types of characters you've drawn. Pay attention to their comments and see how well you've communicated your ideas with your pencils. (Afterwards, if some characters were not easily identified, try to figure out where your mistakes were made. It is important to learn from your mistakes and try again. If your characters were easy to identify, then pat yourself on the back—but take the pencil out of your hand before you do this!)

"I LOVE THESE BED AND BREAKFAST PLACES!"

**B**ob Zahn has been one of America's most successful freelance cartoonists for many years. His highly marketable ideas and popular style have made him one of the most widely and frequently published freelancers around.

Zahn made five dollars for his very first cartoon sale in 1957 to *Good Humor* magazine, after nearly a year of trying and failing and trying again. Although Bob claims his work was pretty lousy in the beginning, it didn't take him long to become one of the best freelancers in the business. Since that first sale, more than 10,000 of his cartoons have appeared in *Good Housekeeping, Boy's Life, New Woman, Playboy, Woman's World, First, National Lampoon, Saturday Evening Post, National Review, National Enquirer, Medical Economics,* and countless other magazines worldwide.

Zahn has also produced three syndicated comic strips and panels ("Hap Hazard," "Bigg's Business," and "McCobber"), which have appeared in more than a hundred newspapers.

Recently Bob has ventured into the greeting card business. More than a hundred different cards feature both his art and ideas. Greeting card work brings some variety into Zahn's studio, helps keep him fresh, and brings his work to an important and profitable audience.

Bob Zahn began his career without any formal art training, but cites Al Capp's "Li'l Abner" as an early influence on his work. These days Bob lists *New Yorker* cartoonists Jack Ziegler and George Booth among his favorites, as well as "The Far Side" creator, Gary Larson.

Zahn is a full-time freelancer now, but for most of his career his magazine cartoons and comic strips were all created in the evening and on weekends. For thirty years Bob spent his nine-to-five hours working as a staff designer, illustrator and cartoonist for General Electric in Syracuse, New York. At GE, Zahn was able to draw all day long (for visual aids, slides, booklets, corporate brochures, signs, logos, graphs, etc.) and still receive a steady, dependable paycheck. Drawing for General Electric gave Bob a financially secure outlet for his talents, while freelancing allowed him the freedom to use his talents acccording to his own terms and tastes . . . and bank plenty of extra income for his family. Although it was not always easy to draw for a large corporation all day, then come home and draw cartoons after dinner, Zahn says "I liked it too much not to do it."

Although Zahn believes that fax machines, word processors and computers can be very important and helpful tools for a cartoonist, he keeps his own tools pretty basic and simple. He uses felt-tip pens for his inking, and designer markers for color work. After all these years, Bob continues to experiment with a variety of papers for his drawings, but says he usually prefers to use a good, heavyweight paper from a stationery store.

During his many years in cartooning, Bob has seen countless cartoonists appear and disappear from the business. "I think I've been successful," says Zahn, "because I keep putting the work out through good times and bad. All magazine cartoonists are going to get a ton of rejects; it's simply the nature of the business. If you let the rejects get you down, you stop drawing and if you stop drawing, the sales stop, and after a while you're out of business."

Now enjoying his retirement from General Electric, Zahn divides his time between the drawing board and the golf course. After thirty-five years in the business, Bob Zahn continues to create some of the very best magazine cartoons with all the joy and enthusiasm of a beginner.

# How to Develop Your Own Style & Characters

**E**very good cartoonist must strive to have his own individual style. Style is more than the ability to draw well—it's your identity and your trademark. Your style is what makes your cartoons uniquely yours. It is what sets your cartoons apart from the crowd. By having your own individual style, you can be sure that no other cartoonist will be getting the credit for the creations that have sprung from your brain and pen. Just as Ford doesn't want to be mistaken for Chevrolet or Chrysler, you don't want your cartoons to be mistaken for someone else's or vice versa.

The very best cartoonists all have unique, individual styles and their work can often be identified at a glance, even without a signature. When you think about your favorite cartoonists, you can instantly see a picture in your mind of their styles. When you think about the drawings of Charles Schulz, your mind sees slightly nervous, insecure lines that echo the slightly nervous, insecure characters he draws. Conversely, Jim Davis uses strong, bold lines to draw his strong, bold cat, Garfield. Johnny Hart's loose, freewheeling line work is perfectly suited to the loose, freewheeling characters in "B.C." The late Charles Addams created his legendary Addams Family characters for the *New Yorker*, using lots of dark wash and shading, which were perfect for his dark and shadowy characters and macabre humor.

Pick up a copy of today's newspaper or any issue of the *New Yorker* or *Mad* magazine, look at the multitude of different cartooning styles in those pages and notice how each cartoonist stands out from the crowd with looks and personality. This is the kind of uniqueness and greatness you should strive for in *your* cartoons!

One factor that will determine your style, is plain old genetics. You are a one-of-a-kind, unique individual and to some extent your natural drawing style

Every good cartoonist has an original style. What's yours? Here is a friendly office worker guy as he might be drawn by three different cartoonists. Notice how each style changes the character's look and personality. The version on the left has a zanier look, the version in the middle looks a bit more sophisticated, and the version on the right has a more whimsical quality.

will probably be as individual as your fingerprints. You can study cartooning and practice and imitate others, but the basic foundation of your style is uniquely yours. If you are a silly person, you will most likely develop a silly style. If you are an eccentric person, your style will probably reflect that in some way. Or you may have the kind of personality that will inspire you to create massive, muscular superheroes for comic books.

The other factor that will affect your style is *influence*. All great cartoonists have been influenced by the cartoonists who came before them and may continue to be influenced by their contemporaries. If your favorite cartoonist has a very light style and draws with quivering lines, there's a strong likelihood that some degree of his style will creep into your own drawings. Unless you specifically try to "steal" his style, the influence will only *enhance* your own individuality and need not *overshadow* it!

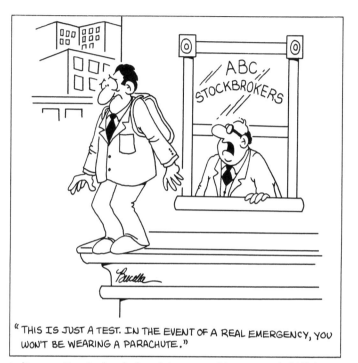

In this cartoon, Marty Bucella grabs the reader's attention with his strong use of solid black areas on the hair, mouth and ties of his characters.

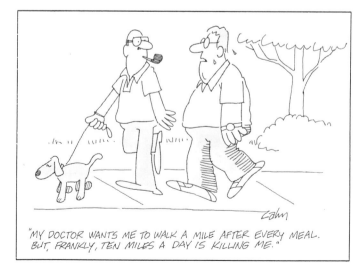

Bob Zahn's cartoons are a perfect blend of simplicity and detail. The simplicity of his characters and background are greatly enhanced by his controlled use of gray shading and small details such as a wristwatch, the details of a collar, the lines on the sneakers, and the design of the pipe.

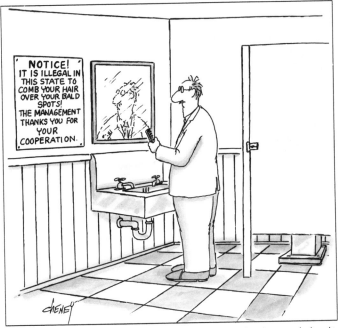

Tom Cheney is a master at bringing richness and detail to his work, without becoming the least bit cluttered. In this cartoon, he doesn't *suggest* what the bathroom looks like; he shows you each and every wallboard and floor tile. In this cartoon, the absurdity of the situation really stands out when contrasted with the realistic setting.

## So How Do You Develop Your Own Style?

Practice, practice, practice! The more you draw, the more your own God-given style will begin to emerge on its own.

Expose yourself to the work of as many different cartoonists as you can. Pay attention to their pen lines, composition, facial expressions, scenery, perspective, the way they use color and shading, etc. Study the work of as many different cartoonists as you can. Study the cartoonists who are successful today and also go to the library to study the work from great cartoonists of the past.

Be free and experiment! Try drawing in a completely different way than you are used to. If you usually draw tight, meticulous cartoons, try doing some with jagged or squiggly lines. Or vice

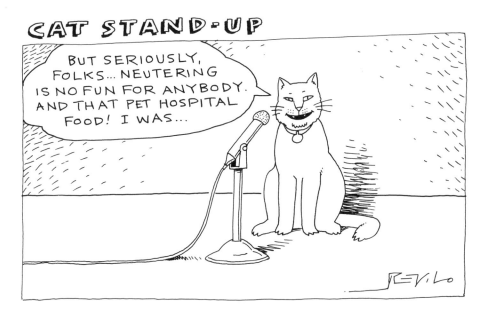

Many of Revilo's cartoons feature semi-realistic-looking characters, sharply contrasted by unrealistic situations. At first glance, his work looks fairly detailed, but notice how few lines he actually uses to achieve this effect.

versa. Athough these drawings will probably look terrible compared to the way you usually draw, you may just find some element worth keeping and incorporating into your emerging style.

Don't steal another cartoonist's style, but feel free to borrow some influence. For example, if you consistently have difficulty drawing women, find out how the great cartoonists draw their women and imitate the legs from one cartoonist and the nose from another and the hair from another . . . try adding these different ingredients to your own recipe and see what happens. If you like the expression you see on a cartoon character, borrow it for your own cartoon, and draw it in your own style and see how it works for you. This is not unethical; it's a cartooning tradition that probably goes back as far as the first cave drawings. (If you become a student of cartoon history, you can trace influences back many years. You can make intelligent guesses on what famous catoonists were influenced by specific cartoonists of the past. It's comparable to tracing the roots of a family tree.)

But, be very careful not to be *over-influenced*! Do not let your drawings become too similar to the trademark work of another cartoonist. Being *too* similar to another cartoonist will make you look both amateurish and dishonest, and astute editors and art directors will purposely avoid you and your work! (There are exceptions to every rule, of course. An animation studio will value your ability to draw exactly like everyone else in the studio. And a successful comic strip artist might hire you as an assistant if you are able to faithfully imitate his drawings. But if you want to blaze your own trail and become legendary in your own right, you must develop your own one-in-a-million style and not look too much like anyone else.)

How do you develop your own special style? Practice, study, borrow, experiment, grow!

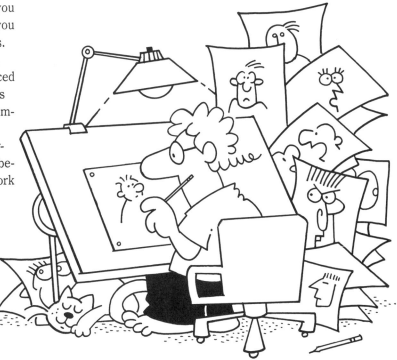

## How to Create Your Own Characters

Characters are the residents who populate your cartoons. A cartoon in a farming magazine will be populated by rural folks in denim. A cartoon in a business magazine will be populated by executives in suits. A comic strip about life in high school will be populated by an assortment of teenagers, teachers, coaches, counselors, custodians, cafeteria staffers, etc.

Characters are all around you. You don't have to create them. They've already been created. Moms have been giving birth to interesting characters since time began. To find interesting characters, you only have to open your eyes and become a sensitive observer of the human race. Take these observations, exaggerate them, embellish them, and you're on your way to creating great cartoon characters!

You don't have to create interesting characters. The world is full of them. You just have to find them!

Creating characters for magazine panel cartoons is fairly simple. To understand and enjoy the cartoons on these pages, you don't need to know much about the characters. Unlike comic strip characters, magazine cartoon characters have no long-term, ongoing relationship with the reader. The humor in these cartoons comes mainly from the situation, not the characters.

*"Desperate, ambitious cartoonist seeks fascinating cartoon character for fun, laughter and profit. Would like to settle down to long-term relationship. Reply A.S.A.P."*

*"Don't be alarmed, son. Growth spurts are normal for a boy your age."*

## Creating Characters for Magazine Cartoons

Magazine cartoon characters are fairly easy to create because the format doesn't allow the reader to develop much of a relationship with the character. With rare exceptions, the characters are not recurring or well defined. In most magazine cartoons the characters are fairly generic stereotypes.

For example, a magazine cartoon in the *Wall Street Journal* may show a middle-aged executive behind a desk bawling out a younger employee. Creating these characters is fairly simple: the middle-aged executive is fat, balding and wears glasses; the younger employee is thinner, has more hair, looks more alert, wears a less conservative tie. These are stereotypes that are easy to draw and quickly tell the reader who the cartoon is about. To enjoy this one individual magazine cartoon, the reader doesn't need to know if the older man is a widower or what his favorite food is or if he

has allergies or if the younger employee is married or single or a Methodist or a Pisces or a Kiwanis.

To populate your magazine cartoons you must learn how to draw a wide variety of easily identified stereotypes. Learn how to draw a mom, a preschooler, a teenage boy and girl, a baker, a fireman, a cat, a dog, a disk jockey, a rock star, etc.

To create magazine cartoon characters, you must ask yourself: A) Who is this person who is speaking? and B) What is he saying or doing that is funny? The reader doesn't need to know any more than this. In magazine cartoons, the funny gag is more important than the broader personalities of the characters involved.

*Richard makes friends easily. Unfortunately, he makes them out of Play-Doh.*

"My feet don't smell so bad today. I've
got a breath mint between each toe!"

"It's an ailment I see mostly in
December. It's missile-toe!"

"My hairdresser was feeling a little too
creative today."

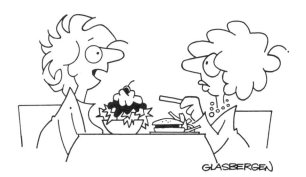

"I'm easing into my diet gradually. It's a
hot fudge salad!"

## Creating Characters for Comic Strips

Creating characters for comic strips is far more complex than creating characters for magazine cartoons. We know very little about the kid in the cartoon on page 47 in last month's issue of *Good Housekeeping*, but we know all the idiosyncrasies of the characters who populate "Peanuts," "Beetle Bailey," "Calvin and Hobbes," "Broom Hilda" and other favorite comic strips.

Comic strip characters are much more complex than magazine cartoon characters because we have an *ongoing* relationship with our favorite comic strip characters. Comic strip characters enter our life every day of the week, year after year, decade after decade. We get to know them pretty well. Sometimes we almost think of them as being real people.

To keep our attention for five, ten, twenty, thirty years or more, a comic strip character must be a very interesting and amusing person or animal! Creating an entire cast of characters who can hold the attention of millions of readers for several years is an awesome challenge! This challenge may be enough to frighten you away altogether, but remember: Others have done it, they started out as inexperienced and raw as you are, but somehow they found a way to create legendary characters and perhaps you can do it too!

To create your own legendary comic strip characters, you'll need a burning desire to succeed. Getting a comic strip successfully syndicated is a very difficult task and only the very best will succeed. The road to comic strip stardom is paved with rejection and discouragement, but the longer you stay on that bumpy road, the closer you'll get to your destination. The first step is to create a cast of funny, interesting characters.

Comic strip characters are part of our lives, day after day, year after year. They become friends and we get to know them fairly well. Creating good comic strip characters is far more complex and much more difficult than creating characters for magazine cartoons, political cartoons or humorous illustrations.

## So How Exactly Do You Go About Creating Good Comic Strip Characters?

• **Study the comic strips in the newspapers.** Think about the characters you see and ask yourself what makes each character special? What makes each character funny? Why do readers like this character?

• **Study other classic characters from successful television, movies and plays.** Think about Bob Hope and what made him such a big star. His jokes were no better or worse than a thousand other comedians, but his personality, his characters, made him a star! The same thing can be said about Laurel and Hardy, Jack Benny, John Belushi, Gilda Radner, The Fonz, The Muppets, The Marx Brothers, Eddie Murphy, Ralph and Ed from "The Honeymooners," Phyllis Diller, Red Skelton, Lucille Ball, Felix and Oscar from "The Odd Couple," Robin Williams, Bob Newhart, Rodney Dangerfield, John Candy, David Letterman and so on. *What is it about these funny people and their characters or personality that makes you remember them long after you've forgotten anything they've ever said?*

• **Take a close look at your friends and family. Are there any characters there?** Johnny Hart says that most of the characters in his famous "B.C." comic strip were based on personal friends, family, in-laws and co-workers! Hart lampooned their looks and personalities and wound up with one of the most famous and successful comic strips of all time. Likewise, Hagar The Horrible, with his enoromous belly and hairy features is the mirror image of his creator, the late Dik Browne.

SKETCH
SKETCH

Interesting characters are all around you! Take a *closer* look at your friends, family, schoolmates, associates, co-workers and acquaintances. Would anyone you know make an interesting cartoon character?

• **Sit down and try to create some characters of your own.** Just DO it! Experiment and play with different personalities in your sketch pad. Just for fun, create a cast of characters for some sort of comic strip. Don't worry about selling it or getting it published, just do it for fun and practice. *First get good; later you can get professional.*

• **Remember to make your characters visually unique and interesting.** Make each character look distinctive with memorable features. Think about Popeye's forearms, Charlie Brown's enormous round head, Sergeant Snorkel's bulldog jaw, Dagwood's strange haircut, Ziggy's balloonish head and body, Hagar's girth and horns, Bart Simpson's saw blade haircut, etc. Find a way to bring something memorable to the appearance of your own characters.

## Homework

❶ Draw an insurance salesman in your own natural style. Then draw him again with squiggly lines. Then draw him again with lots of intricate details (facial lines, clothing patterns, hair texture, shiny shoes, etc.). Then draw him again with as few details as possible, drawing only the barest of essential details. Then draw him again with exaggerated, grotesque features (huge nose, tiny head, inflated belly, long legs, short feet, etc.). Draw the same insurance salesman in as many different styles as you can create. (How would your favorite cartoonists draw an insurance salesman? What can you borrow or learn from their approach?) This exercise will help you discover and develop your own special style.

❷ Just for practice, create a funny comic strip about a group of factory workers.

First, create your star character. What does he look like? What does he act like? What interesting quirks does he have? What makes him likable and distinctive? What is his job?

Next, create your star character's co-workers and family. Is your star married? Does he have a girlfriend? Does he have kids or nieces and nephews or grandchildren? Who does he work with? Who is his boss? Does he have any enemies? Does he have any pets? What is special about each of these people? What do they look like? What do they act like? Are they similar to anyone you know personally? Do you work or go to school with someone who'd make a funny cartoon character?

Remember to make each character look and act differently from the others. Also, try to give each character a purpose, a reason for being in the comic strip. Make sure your characters have reasons to interact with each other, to fight, to love, to talk, etc.

❸ Try doing a few practice comic strip drawings with these characters. In upcoming chapters you'll learn more about writing funny ideas and doing professional layouts, but for now just wing it! Create your cast, put them inside some panel boxes like the comic strips you read in the paper, and see if you can think of something funny for them to say and do. It's practice time and nobody is watching or judging you, so just play with your cartoons and have some fun!

## Cartoonist Profile:
# REVILO

## AUGUST IN THE CITY MADE OF CHEESE

**R**evilo (a.k.a. Oliver Christianson) creates gourmet cartoons for the cartoon connoisseur. His ideas are usually more than a little bit warped and seem to come from somewhere on the outskirts of the Twilight Zone. While Revilo's demented cartoons are less mainstream than most traditional cartoonists, he, ironically, is employed by one of the most mainstream and traditional companies in the world: Hallmark Cards.

At Hallmark, Revilo is both a writer and a humorous illustrator. He works with a small studio of selected artists and writers to create great material for a variety of Hallmark product lines, including Hallmark, Ambassador and Shoebox cards, calendars, postcards, coffee mugs, notepads, T-shirts, gift items, etc. The best examples of Revilo's current work can be found in any Hallmark store. His Hallmark postcards rank among his best work and are some of the funniest cartoons published in America today.

While his Hallmark career gives him a sociable working environment and financial security, Revilo also enjoys freelancing for magazines in his spare time. His gag panel cartoons have been published in *Penthouse*, *In Health*, *New Woman*, *Esquire*, *Bostonia* and other publications. Some of Revilo's wildest and funniest cartoons can be found in *National Lampoon's Cartoon Book*. His unusual cartoon-novel *Pigs In Love* was published by Clarkson N. Potter in 1982.

When Revilo was a young boy, his father had been a staff cartoonist for *Leatherneck* magazine while serving in the U.S. Marine Corps. "I was exposed to all kinds of cartooning and fine art from birth on. I'm not sure if this is child abuse or not, but it's close! My earliest memories of drawing are from when I was about five years old. I would listen to radio programs and illustrate what I thought was going on. I think this sort of exercise did a lot to help develop my imagination. Basically, though, I guess I drew because my father did. I'm only glad he wasn't a serial killer." Later Revilo broadened his education with a BFA and an MFA in illustration.

Although Revilo began his career exclusively as a magazine cartoonist, he found that too many of his markets were going out of business — often right after they started buying *his* cartoons. "I don't know if there was a connection there, but I've always had my suspicions. My only goal in this business has always been to *stay* in this business, and I've managed to do that only because I was flexible enough to shift my focus from magazines to greeting cards."

Before Hallmark, Revilo was a top writer and illustrator for American Greetings Corp. in Cleveland, Ohio. "My involvement with the greeting card industry didn't begin with American Greetings. When I lived in Los Angeles, I would occasionally sell a cartoon to a friend who was the buyer for a West Coast card company called Windemere Press. It all started innocently enough, a card here, a card there — I had no intention of making a career out of greeting cards; after all, I was a well-known *magazine* cartoonist! Anyway, one thing led to another and before I knew it, I was in too deep to ever escape!! It's a tragic story! Seriously, though, I really like working at Hallmark and I feel a lot more freedom inside the corporation than I ever did freelancing.

Freelancing is tough. I found it difficult and didn't shed any tears when I left that way of life."

Although Revilo continues to freelance for magazines on a part-time basis, he manages this with the assistance of his wife, Sylvia, whom he met while working at American Greetings. "My wife is an artist and writer and she's also real good with the business end of things. Since I have a day job, I'm not around when clients call, and she takes care of things. It's nothing we planned, it just sort of happened. She also does all of my mailing and occasionally she does the color on my black-and-white pieces."

Among his influences, Revilo credits legendary cartoonists Virgil (Vip) Partch, Charles Addams, Wallace Wood and B. Kliban. "As for other humorists who've influenced me, I'd have to mention Jackie Vernon, the old deadpan, stand-up comic from the "Ed Sullivan Show." I feel very close to Jackie in a lot of ways, the guy had terrific delivery — sort of like a mortician selling Girl Scout cookies."

To create his own funny ideas, Revilo has no particular system or routine. "I try to make my mind go completely blank and ideas just come to me. The more I *try* to have ideas, the less happens! I don't intentionally try to be offbeat, it's just my natural perspective I guess. I'd love to be able to sit down and crank out lots of cute, general-interest cartoons; I'd probably be making a lot more money, but I'm simply not able to."

Revilo's not-so-cute cartoons have earned him a strong cult following and his work is highly respected by top editors and art directors. His freelance work, combined with his salaried Hallmark creations, add up to a very creative, productive and successful career.

Revilo believes that he has been successful because he loves his work. It may also be because millions of fans also love his work.

The most commonly asked question any cartoonist ever hears is, "Where do you get your funny ideas?" And the most common answer is, "I'm not really sure!"

Funny ideas are a very strange thing to create. You can't just put a bunch of funny ingredients together in a pan, stir them up, and create a cartoon idea. Ideas are a very mysterious and intangible commodity. Ideas are odorless (except for ideas that stink), tasteless (sometimes the most tasteless ideas are the funniest) and invisible (actually, some ideas are better off unseen). So where do cartoon ideas come from and how do you know if you've got a good one?

Certainly you've heard the term, "a sense of humor." Humor is exactly that, a *sense*. You either sense that something is funny, or you don't. With experience and practice, you will develop your sense of humor and become a better judge of what is and is not funny. But because humor is a sense and not an exact science, you'll *never* be 100 percent certain whether an idea is absolutely funny or not.

To be honest, this book cannot teach you how to write funny ideas. This book can offer tips, suggestions, advice and shortcuts, but only *you* can teach yourself how to write funny ideas. *Quite simply, you will learn it by doing it.*

*If you want to sell your cartoons to magazines and newspapers, it is more important to be a great gag writer than a great artist. A great idea will sell a poor drawing, but a great drawing will rarely sell a poor idea!*

## Bad News and Good News

The bad news is, in the beginning you may not be very good at writing funny ideas. The good news is, you'll get better with practice.

Most successful cartoonists began their careers as very successful failures. You're probably no different from most cartoonists . . . in the beginning you're likely to bomb, even if your drawings are great. Learning how to be funny takes time, practice, patience and experience.

How quickly you improve at creating funny ideas for cartoons depends on several factors: the amount of natural talent you were born with, how much you study your craft and immerse yourself in humor, how often you practice, and whether or not you get discouraged or just keep on plugging away.

Your first gag ideas might stink. (But that's normal, so don't worry. You'll get better!)

## Tips on How to Think Up Funny Ideas

1. **Study other funny ideas.** Start reading a *lot* of magazine cartoons, newspaper comics, humorous cartoon books. Also start spending some time in greeting card shops, reading as many different funny cards as you can. Buy or borrow books by Dave Barry, Woody Allen, Erma Bombeck, P.J. O'Rourke and other humorists. Find some big, thick humor anthologies and read them from cover to cover. Start a personal humor library and refer to it often. *Exposing yourself to an enormous amount of funny ideas is the fastest way to develop your own sense of humor.*

2. **Imitate great cartoonists and humorists and learn as much from them as you can.** By all means, do not steal from them. But do use them as cre-

ative role models. Pay attention to what makes their work special and then apply it to your own ideas. When you learn to recognize the ingredients of humor in other people's work, it will become easier to add those ingredients to your own cartoons.

For example, if Garfield consistently gets a laugh with slapstick humor, try it in your own cartoons. If you're a fan of outrageous "Far Side" or Kliban cartoons, try imitating that style of humor and see what happens. If you are a big fan of Bart Simpson, try adding some verbal wisecracks to your own cartoons and see how they measure up. If you enjoy the satire of *Mad* magazine, try attempting a satire of your own, using *Mad* as a standard to aspire to. A child learns how to walk by imitating his parents; a freshman learns how to play good foot-

ball by imitating a senior; a person learns how to become an executive by imitating the behaviors of succesful executives; you will learn how to write funny ideas by trying to emulate humorists you admire and respect.

3. **Subscribe to *Gag Re-Cap* magazine.** The *Gag Re-Cap* is essential reading for any cartoonist who needs to write funny ideas. Each monthly issue brings you a comprehensive and up-to-date summary of hundreds of cartoons published in major and middle-class cartoon markets during the previous months. Reading the *Gag Re-Cap* will keep you current on exactly what cartoons the best magazines are buying from month to month . . . without the trouble and expense of having to go out and actually buy each magazine. Each listing in the *Re-Cap* tells you who sold what cartoon to each market, how much was paid, and gives a complete description of the cartoon and caption. Hundreds of professionals rely on the *Gag Re-Cap* every month to stimulate creative thinking and funny ideas. If you are serious about car-

tooning, write for subscription information to the *Gag Re-Cap,* Box 774, Bensalem, PA 19020.

4. **Keep your ideas fresh and original.** Nobody wants to see a cartoon that's been done to death. So avoid the obvious and stay away from clichés, unless your variation is really something special. If a cartoon idea seems obvious or familiar to you, put it aside and try for something fresher. Your editors and your readers will thank you. The more cartoons you read, the easier it will be to catch yourself when you start serving up stale, old, wrinkly leftovers. Cartooning is a very competitive business that thrives on the freshest of ideas.

5. **Develop a humor writing routine.** Don't sit around waiting for inspiration to hit you! Find out what puts you in the right frame of mind for creating funny ideas and make it a habit!

If you feel more creative after a nap, then make a nap the first step of your personal Humor Writing Routine every time you write ideas. If you feel more creative after taking a brisk walk, then

**Creative Tip:** A little exercise can give you a creative energy boost! If the ideas aren't flowing as quickly as you'd like, try getting out for a brisk walk or hop on your bike or spend some time on your indoor ski machine. If you are in good health, fifteen or twenty minutes of comfortable exercise can increase your energy and make creative thinking much easier.

If you want to be a great athlete or musician, you've got to practice regularly. The same rule applies to gag writing!

get into the habit of taking a brisk walk every time you prepare to create funny ideas. If a cup or two of coffee helps you be more creative, then make this part of your Humor Writing Routine. If you write ideas better in the morning, then always try to do your writing in the morning. Maybe meditation is your secret weapon . . . or prayer . . . or jogging . . . or reading . . . or eating something loaded with sugar . . . or pacing . . . or biking . . . or visualization . . . or weight lifting . . . or watching television. *Experiment . . . find out what stimulates your creative energy and stick with it!*

Your Humor Writing Routine will help you set up a pattern for success and give you more confidence when facing that intimidating blank sheet of paper. For example, suppose that yesterday you went jogging and had a cup of coffee before you sat down to create some cartoon ideas and it really sparked your plugs and you had a very productive session . . . today you should set up the same pattern and expect to achieve the same results. In other words, don't just sit and wait for ideas to come to you. Do something positive, take some kind of action to *make* the ideas come to you. *Once you establish a routine for successful writing, successful writing will become part of your routine.*

6. **Write about the things you know best.** The humor in your gag ideas will ring truer and usually be much funnier if you write about something you have experienced yourself.

Imagine that two cartoonists are both attempting to write funny gag ideas about marriage. One cartoonist has never been married; the other has been

married for fifteen years. Obviously, the married cartoonist has a much broader base of experience from which to draw his humorous observations. The bachelor cartoonist, conversely, would probably be better equipped to create funny gags about dating, loneliness, freedom, TV dinners, etc.

Keep in mind, however, that you don't have to *be* an astronaut to write cartoons about astronauts . . . although it would be helpful. A good cartoonist can write ideas about almost any subject. But your best cartoons will have their genesis in your own personal, real-life experiences.

7. **Know your audience.** You can write for yourself and your own personal interests and get results, but you will achieve greater success when you learn to write for your audience. First, decide who your audience is. Then create cartoon gag ideas that you believe they would be interested in. For example, cartoons sent to *Good Housekeeping* should deal with topics generally covered in that publication: pets, children, marriage, budgets, home furnishings, women's career and personal interests, etc. Conversely, a batch of cartoons aimed at *Playboy* should contain cartoons of a vastly different nature: sports, stereos, cars, motorcycles, booze, romance, dating, sexuality, etc. If you are creating cartoons for a trade or special-interest publication, your ideas must be tailored even more specifically: fishing and hunting gags for *Field & Stream*, medical and medical business gags for *Medical Economics*, young adult interests for *Campus Life*, and so on.

Even the best cartoonists get writer's block now and again. But you can learn how to overcome it!

Cartoons for comic strips tend to be much broader in nature than magazine cartoons, because you are reaching an extremely broad readership and an enormous cross-section of the reading public. Still, even in this vast forum it pays to know your audience. Newspaper readers tend to expect nice, wholesome and fairly conservative cartoons with their morning coffee . . . it's early in the morning, they don't want to be shocked or outraged, they just want an easy grin before their day starts to roll downhill. But remember, even in the comic strips there are special interests to cater to. For instance, "Cathy" reaches a primarily young, female readership; "Luanne" is geared toward young teens; "Doonesbury" is created for a socially/politically aware crowd; "The Better Half" is tailored for middle-aged, married readers; etc. (If *your* comic strip can reach an important segment of the readership that is currently being overlooked, you'll be a very valuable and successful cartoonist!)

8. **Be careful with your subject matter.** Certain subjects are generally considered tasteless, offensive and taboo. Unless you are purposely trying to be offensive for a particular publication, be careful of topics that my upset readers or editors. Do not make fun of the mentally ill or the physically challenged. Be careful about racial and sexual offenses. You might write what you consider to be a hilarious gag about heart attacks, but it won't be very funny to the editor or reader whose husband died last week from cardiac arrest. Unfortunately, there will always be some reader who is upset by even the slightest of-

fense, such as a humorous reference to baldness, but you can't please *everyone* no matter how careful you are.

9. **Schedule time to practice your writing often, daily if possible.** Like most any skill, the best way to improve is by doing it over and over and over and over on a frequent basis. The old rule of "Use It or Lose It" applies to most skills: music, athletics, dancing, and yes, gag writing. Most cartoonists report best results when they write nearly every day. In fact, the hardest time to create funny gag ideas is usually after a long vacation; it takes time to dust off those funny bones and get them back into top condition. To keep your mind sharp, you don't have to schedule marathon idea sessions; an hour or two every other day would be plenty for the part-time cartoonist. (As a beginner with limited time, you might benefit best by writing for an hour or two one day, then drawing the next day, and continuing to alternate the two from day to day.)

*The more you practice writing funny ideas, the better you will get.* Even very successful cartoonists will tell you that they are continuing to improve even after ten, twenty, thirty or more years in the business! There is no substitute for hours of practice and years of experience.

10. **Learn now to edit and revise your ideas.** Your goal should be to communicate your funny cartoon idea as simply and effectively as possible. Reading and understanding your cartoon should be easy for the reader. It's not the reader's job to figure out what you're trying to say; it's your job to communi-

If you want to be a successful cartoonist, you must learn how to think funny!

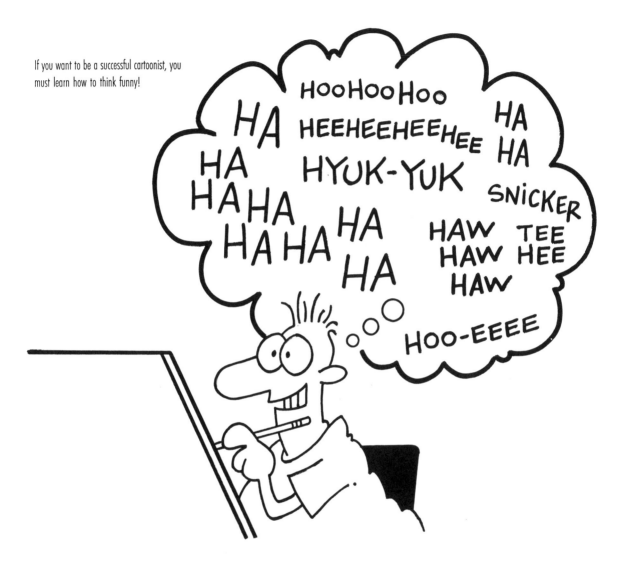

With practice, a good cartoonist can learn to find something funny about almost anything.

cate clearly. Be sure to weed out any redundant or unnecessary words in your captions. Make sure your spelling is correct and your grammar is effective. *Every good cartoonist is a writer first and an artist second, so make sure your writing skills are sharp!* (If you are still in school, be sure to make Language Arts one of your strongest subjects. If you are out of school, it would be extremely wise to take a night class in creative writing.)

11. **Don't get discouraged by occasional "writer's block."** You're not a machine; you're human. Your behavior and performance are going to vary from day to day. You're going to have bad days now and again when you can't write a thing, no matter how hard you try. This happens to everyone, regardless of their degree of success or experience. (Many successful cartoonists hire assistants to help them keep a steady flow of ideas going.) Stress, fatigue, discouragement, illness, boredom, a case of the doldrums, worry, distractions, or just plain staleness: all of these can block the flow of creative energy on occasion.

The most effective way to beat

writer's block is to remove or manage the stress that has caused it. Instead of getting upset and frustrated, try to relax and just roll with it. Most cartoonists report that it just doesn't pay to fight a bad day . . . staring and cursing at a blank sheet of paper is only going to make things worse. When you hit a dry spell, just forget about writing cartoon ideas for a little while and go do something to clear your mind and help you relax. Go for a long walk, visit a museum, take a nap, see a movie, or spend a few hours wandering around a mall . . . then come back later and try again to create some funny gags.

If you're having a prolonged and chronically unproductive dry spell, take a few days off from cartooning if you can. Maybe all you need is a rest and a brief vacation. If your creativity continues to stay away, take a closer look at your life and the stresses you're facing . . . is there anything you can change to make your life less stressful and therefore more creative? (Are you gettting enough exercise, enough sleep? Do you have any bad habits that may be affecting your health and creativity? Are your goals strong enough to ignite your creativity?) *Remember, if you want things to change, then you must make changes.*

Unfortunately, in everyone's life there will be occasional obstacles to creativity that cannot be so easily or quickly changed. A death in the family, illness, divorce, the loss of a job, these are stressful situations that will absolutely crush your creativity—but as the pain and stress subsides, your creativity and sense of humor will return.

GLASBERGEN

*"Having nine lives is cool, but if I have to go through menopause nine times, forget it!"*

12. **Finally.** If you want to write funny cartoon ideas, the most important thing you must do is—**Learn to think funny!**

On these pages are cartoons that were all purchased and published by editors of top publications. What is funny about them? What is not funny about them? If you were an editor, why would you buy (or not buy) these cartoons for your magzine?

- Learn to use and enlarge your imagination.
- Learn to see things differently from the way everyone else sees them.
- Learn to twist sense into nonsense.
- Learn to twist nonsense into sense.
- Learn to exaggerate.
- Learn to understate.
- Learn how to create surprises.
- Learn to break the rules. (If someone expects one plus one to equal two, find some unusual way to show them that one plus one can equal forty-seven!)
- Learn to find outrageous solutions to ordinary problems.
- Learn to find ordinary solutions to outrageous problems.
- Learn to turn serious things into silly things.
- Learn to turn silly things into serious things.
- Learn to expect the unexpected.

*"Swiss Army golf clubs!"*

Try to use these cartoons (and the other cartoons in this book) to stimulate creativity and help you think up your own cartoon ideas.

*"When I push the garage door control, his mouth opens and closes!"*

*"The 'D' from my math teacher is really an 'A'. He's not very good at spelling."*

## A Personal Anecdote: How I Learned to "Think Funny!"

Although I always enjoyed drawing, I never took any serious interest in cartooning until junior high school. In 1971, at the tender and eager age of fourteen, I began writing dozens of fan letters to my favorite cartoonists. In each letter I asked for some advice and words of wisdom on how to become a rich and famous cartoonist. Within a few weeks, I began to receive many fascinating replies (many of them accompanied by auto-

graphed drawings) from such illustrious catoonists as Mort Walker, Charles Schulz, Russel Myers, Garry Trudeau, Jack Davis, Bill Hoest, Bil Keane, Chester Gould, Bob Weber, Mel Lazarus, Jay Ward, Lee Lorenz, Henry Martin, Orlando Busino, Jared Lee, Sid Harris, Gahan Wilson, Alden Erickson, Don Orehek, Bud Sagendorf, Paul Coker, George and Virginia Smith, J.B. Handlesman, Gordon Bess, T.K. Ryan, Bud Blake, Morrie Turner, Brant Parker and others. The replies varied in length, but each contained some pearl of wisdom that helped me get just a little bit closer to my own goal of cartooning success. My daily trips to the post office were as exciting as Christmas morning!

On one such pilgrimage to the post office, I received a letter from Johnny Hart, creator of "B.C." and "The Wizard of Id." His package contained an autograph and a letter that contained two very brief words of advice: "Think Funny!" At first, two short words didn't seem like a whole lot of advice and I felt a little bit cheated by the brevity of his guidance.

Later that evening, after I washed the dishes, cleaned my room, and finished my homework (if you're very quiet you can hear my parents laughing very loudly at this part), I went out for a relaxing stroll around my rural upstate New York village. As I walked, I thought about the "Think Funny" advice I'd received earlier that day. "Think Funny,

*"If you're interested in a lighter meal, try our new Bucket of Feathers!"*

what the heck is *that* supposed to mean?" I wondered. At first I felt annoyed by this advice, but soon it became a challenge.

As I continued my walk around the streets of my small town, I noticed a large crack in the sidewalk. With Hart's "Think Funny" advice gnawing at me, I looked down at that crack in the sidewalk and decided to find something, anything funny about it. My mind started getting playful. What would happen if a nurse saw that crack in the sidewalk . . . would she put a bandage on it? What would happen if a family of ants encountered that same large crack in the sidewalk . . . would they take pictures like tourists at the Grand Canyon? Ooh, this was becoming fun!

Next, I tried this little "Think Funny" game with a telephone pole. The phone pole was covered with many large staples, leftover from numerous posters and garage sale signs. What could possibly be funny about this, I wondered? Maybe the staples were actually there as steps so the phone company could obey the Equal Opportunity laws and hire very tiny linemen to climb the poles. As I continued my walk, I saw a cemetery stone with a firefly over it and thought up some awful idea about a ghost who was smoking a cigarette.

The ideas that came to me while playing this game weren't necessarily hilarious (after all, I was only fourteen!), but as a form of mental exercise it was unbeatable. Just as a young athlete would train his muscles to help him become a better player, I was training my brain to help me become a better cartoonist.

Realizing I'd discovered something very useful, I made my "Think Funny" game a regular part of my daily routine and practiced it frequently each day. After more than twenty years of playing this game, I've been able to sharpen my sense of humor and become a very adept humor writer. I've conditioned my mind to find something humorous in almost any situation. "Think Funny" is no longer a game I play; it is a business skill that has become a normal and vital part of my workday.

*Cartoonist Profile:*
**MARTHA CAMPBELL**

*The New Breed*

12-5

Martha F. Campbell

Martha Campbell is living proof that you don't have to live in The Big City to be a successful cartoonist. Martha Campbell lives in Arkansas with her husband, children and a cocker spaniel who sleeps under her drawing board.

Since 1973, Martha has been one of America's top freelancers and has created and sold thousands of magazine cartoons and humorous illustrations. Her cartoons appear regularly in *Good Housekeeping*, *McCall's*, *Family Circle*, *Wall Street Journal*, *Saturday Evening Post*, *TV Guide*, *Cosmopolitan*, *Sesame Street* magazine, *Reader's Digest*, *National Enquirer* and in numerous trade and religious publications. She has also illustrated several books, magazine articles and calendars. A collection of her best cartoons was published in 1987 by Ballantine Books.

As a child Martha Campbell loved to draw and was strongly attracted to the artwork in her favorite newspaper comic strips. She was especially fond of "Bringing Up Father" (featuring Maggie & Jiggs) and "Blondie." Later Martha earned a BFA from Washington University-St. Louis School of Fine Art, with a major in illustration. In her senior year, a recruiter from Hallmark Cards came to Washington University and hired Martha to join their art staff in Kansas City. As an artist in the Contemporary Card department, Martha created humorous artwork for their line of tall, thin studio cards. As an unexpected part of her job, Martha was required to write and submit a minimum of ten funny card ideas each week. Prior to this, Martha had only thought of herself as an artist and had never paid much attention to any form of humor writing. Learning how to write greeting card gags for Hallmark was excellent training for the cartoon gags she would later create as a freelancer.

Working for a large greeting card company like Hallmark, being a part of an enormous creative atmosphere, is an experience Campbell heartily recommends for any aspiring artist or cartoonist. When asked for additional advice for the hopeful cartoonist, Martha says, "I think an aspiring cartoonist should know how to draw well—there's nothing more distracting than a bad drawing. He should also have a reasonable vocabulary and know how to spell." To create good gags, she believes it is extremely important to know a little bit about as many subjects as possible. When the aspiring cartoonist is faced with rejection, Martha advises: "Don't try to figure out why he rejected your work. You'll be able to think of a whole lot of reasons, but they'll all be from *your* head, not *his*!"

The key to Campbell's success is her ability to turn out superior work with great consistency. She doesn't let herself get bogged down by rejections or by occasional periods of slow sales that are unavoidable and common to all freelancers. "I'm good at doing inoffensive, neutral cartoons on any topic—and I never stopped mailing! You sell 'em because you mail 'em and you mail 'em because you sell 'em."

Although there are very few female magazine cartoonists, Martha doesn't think gender makes much difference in this business. "I wouldn't be able to tell the difference between cartoons done by men and ones done by women if I didn't know who did them," she says. "I don't believe I've ever made a sale or lost a sale because I'm a woman. In fact, I think this is one of the fairest competitions between men and women because as creators we're all invisible."

Although Martha Campbell is invisible to her readers, her cartoons are extremely visible. Her sharp wit, consistent hard work and original drawing style make her one of the best and most successful freelance cartoonists in America.

## Teach Yourself How to Play the Think Funny Game

Instead of getting depressed about that pile of unpaid bills on your kitchen table, find *something* funny about it. Think up a totally outrageous and original way to solve this problem and eliminate those bills.

Have you ever seen a pencil with teeth marks on it? What's funny about that? (Whose teeth marks could they be? Dracula, maybe? Why would Dracula bite a pencil? Did he mistake it for a pencilneck geek?)

Next time you find a hole in a wall, take a closer look. Is it really a hole in the wall, or is it the building's belly button?

How would you Think Funny if you found a penny on a hot radiator?

How would you Think Funny in the supermarket if you found a can of diet drink mix in the beer cooler?

How would you Think Funny about a cat sharpening her claws on your brand new stereo speakers? (How would your thinking change if they were someone else's new speakers?)

How would you Think Funny about a refrigerator magnet that keeps falling onto the floor?

Try this: Close your eyes and turn around three times. Open your eyes and find something funny about the very first object you see. (Oh, come on and try it. Don't worry about looking silly. All the *other* people who bought this book are doing it!)

*Learn to find some humor in any situation. This skill will prove invaluable every time you sit down to write cartoon ideas. Exercise your brain and it will get stronger!*

GLASBERGEN

*Good idea: strawberry cheesecake. Bad idea: watermelon cheesecake.*

*"Enjoy yourself, but remember—at midnight the*
*hors d'oeuvres turn into cellulite!"*

*Suddenly the green beast sprang to life and bit Timmy on the nose, laying*
*false Mom's claim that "A little broccoli never hurt anyone!"*

## Homework

❶ Start learning how to Think Funny. Do it today. Go outside for a stroll or a drive and challenge yourself to find something funny about all kinds of common things you see during your outing. (Find something funny about trees, houses, squirrels, dead squirrels, cars, drivers, clouds, blue sky, gray sky, signs, businesses, anything and everything.) Look for something funny wherever you go. Some cartoonists carry a notepad at all times so they can write down funny ideas when they come along. If you think it might be helpful to carry a notepad for this purpose, go buy one *today*.

❷ Establish a Humor Writing Routine. Experiment and find out what really stimulates your creative energy. When you find a routine that works, take full advantage of it and use it habitually. (You'll be *making* creativity happen and this will give you a huge advantage over the cartoonist who is passively *waiting* for creativity to happen!)

❸ Sit down and write five magazine cartoon ideas. They may be great ideas, they may be lousy. The important thing is to get started right away. Get into action and start getting better at it.

If you don't know how to write a magazine cartoon idea, find a book full of magazine cartoons and just imitate what you see. If you see a cartoon about penguins, try to think up your own funny idea about penguins. If you see a cartoon about office workers, try to come up with your own original idea about office workers. Don't *steal* any ideas, but do let yourself be inspired by the work of others. As you get started, your best cartoon ideas will be a blend of both *imitation* and *innovation*. There are plenty of magazine-style cartoons in this book to get you started.

(After you've written your five magazine cartoon ideas, put them aside. Later in this book you'll learn how to draw them up properly and present them to prospective publishers.)

❹ Write five funny comic strip gags. Use the cast of characters you created for your Chapter Two homework, or create a whole new cast.

For right now, don't labor over the art. The important thing now is to get some funny ideas down on paper. Break your funny idea into three or four panels, just like the comic strips in your newspaper. After you've written your ideas, put them aside for a day or two and then take a second look to see if you can revise and improve them in any way. Later in this book you'll learn how to turn your idea into a finished comic strip.

*"I guess I'm not the only one who woke
up in a bad mood!"*

*"As I see it, all the really important
issues are either black or white."*

## Cartoonist Profile:
# MARTY BUCELLA

*"OUR FURNITURE IS FINALLY SAFE. I HAD THE CAT DECLAWED THIS MORNING."*

**M**agazine cartoonist Marty Bucella is not as well known as Charles Schulz or Jim Davis or Gary Larson, nor is he anywhere near as wealthy. But in many ways Marty is every bit as successful as these famous cartoonists! For his entire adult life, Marty Bucella has earned a comfortable living doing something he loves to do: magazine cartooning.

Instead of dragging himself out of bed every morning to scream his way through rush hour traffic, Marty gets to stay home and indulge his passion for cartooning. Because cartooning

allows him to work flexible hours, Marty has had the rare privilege of staying home to raise his two young sons during the day while his wife goes off to work (screaming her way through rush hour traffic). While his children are at school or napping, Marty puts in some quality time with his pen and ink and rounds out his creative schedule during evenings and weekends. This schedule allows him to produce a steady flow of cartoons, which he sells to a long and diverse list of trade and consumer magazines.

Although he spent much of his youth doodling cartoons in his school notebooks, Marty did not plan for a career in cartooning. As a senior in college, Marty created his own greeting cards as a unique way to communicate with and impress his girlfriend (now his wife). Encouraged by her reaction to his work, Marty thought "Hey, maybe I could make some money doing this!" Soon he began creating more greeting cards and submitting them to publishers. Although he failed to make a great splash in the greeting card field, he soon drifted into magazine cartooning and made his first sale in 1977. A trade magazine, *Glass Digest*, bought four of his cartoons and paid him five dollars a piece. Despite this encouraging start, it took nearly three years before Marty's sales were good enough to allow him to leave his parents' home and go out on his own as a full-time magazine cartoonist.

Today Marty Bucella's cartoons seem to appear everywhere. Thousands of his cartoons have sold to *National Enquirer, Good Housekeeping, Reader's Digest, Better Homes and Gardens, McCall's, Woman's World, Family Circle* and dozens of other publications all over the world. Rarely a day goes by that he doesn't sell another cartoon somewhere. In a highly competitive and challenging marketplace, Marty is one of the very few cartoonists who is able to earn a comfortable income *exclusively* from magazine cartooning. However, as his children grow and more time becomes available, Bucella plans to expand his freelancing into other forms of cartooning such

as humorous illustration. (Two of Marty's earliest influences were humorous illustrators Jack Davis and Mort Drucker.)

While many other magazine cartoonists have emerged and quickly disappeared over the years, Marty has remained a top seller because he has learned how to effectively deal with rejection. He understands that there simply isn't enough room to publish every cartoon ever created by every cartoonist; therefore some cartoons will be published and many others will not. He knows that the cartoon that is rejected by one magazine today may very likely be purchased by another magazine next month . . . or next year. Bucella has learned that rejections are a normal part of the business of cartooning, and so he is never seriously deterred by them. This understanding, combined with great work, has kept Bucella in business for many years.

To sell a lot of cartoons, Marty has to write a lot of funny ideas, day after day, week after week, year after year. Like many cartoonists, Marty depends on *Gag Re-Cap* magazine to help him create new ideas. (Additional information on *Gag Re-Cap* can be found on page 53.) Marty explains: "I write my ideas by sitting down with *Gag Re-Cap*. It puts me in the 'gag' frame of mind. It's a strange process. I might read a cartoon about *dieting*. My mind might then think about *fat*, which might lead to *elephants* and how they *never forget*, which might lead to a cartoon about a *memory improvement book* or a *library*. I'm not particularly fond of the writing end of cartooning, but it's the part that is probably the most important. A great drawing will never sell if it has a weak gag, but a great gag will sell a terrible drawing!"

Marty Bucella is successful at selling his cartoons because he is a true pro. He understands the challenges of the business and knows how to accept both the ups and downs. He always gives 100 percent effort to create the best work to meet the needs of his cartoon-buying customers. His gags and his art are equally first rate. Most important, Marty Bucella loves his work and it shows!

**U**nless you're cartooning purely for your own pleasure, you've probably been wondering what you have to do to get your cartoons published. Before you can get your work published, you have to get it into publishable form, using the proper tools, techniques and formats that will make your work look professional.

## Tools of the Trade

Okay, put down that hammer and screwdriver. Those aren't the kind of tools we're talking about here . . . unless you're feeling frustrated and want to massacre your last drawing!

A professional cartoonist's primary tools are pencils, pens, erasers and paper. A trip to an art supply store and a stationery store will provide you with dozens of choices. (A regular art supply store may specialize mainly in paints and canvases, so try to find a good shop that sells supplies for commercial artists.) You would be wise to experiment with many different types of tools as you practice your cartooning.

The first step is to obtain your tools. The second step is to become familiar with them. *Only hands-on practice will show you how a tool really works and whether or not it is right for you. This book*

This chapter will help you make a shopping list so you can acquire all the tools you'll need to create professional-looking cartoons.

The pen is mightier than the sword, but what about the brush? Try both and decide for yourself!

*can introduce you to the basic tools of cartooning, but it is your responsibility to get them and use them. There is no substitute for experience.* Of course, if you have any specific questions about the use, safety or availability of these products, you should talk to your supplier.

Here is a list of several popular cartoonist tools that you should try to obtain and experiment with. If you can't

afford the whole shopping list, then try to obtain these tools a few at a time over several weeks.

Your first trip to the art supply or stationery store doesn't have to be expensive. You only need the basics to get you started. For less than fifty dollars you can buy a few basic tools of the trade. Later you can begin to acquire more supplies and broaden your experimentation.

• **Pencils.** No need to get too technical here. A box of #2 pencils from any department store will do just fine. When you get successful you can invest in an electric pencil sharpener, but for now the sharpener on the back of your Crayola box is good enough.

• **Erasers.** Don't use the eraser on the tail end of your pencil. To protect your drawings, you'll need a softer eraser made especially for artwork. Put these on your shopping list and pick up a few different kinds when you visit the art supply store.

• **Felt-tip pens.** These have become very popular because they are so easy to use and obtain. You can buy fancy felt-tip pens in an art supply store, but many professionals are satisfied with ordinary Flair brand pens found in the supermarket or pharmacy. (All of the author's cartoons and illustrations in this book were inked with this type of pen.) Drawings done in felt-tip do require a little extra care because felt-tip will bleed if it gets wet, so you can't apply a liquid wash to a felt-tip drawing and you must be careful not to shed tears on these cartoons if they don't sell.

• **Metal pen points and holders.** Despite the convenience of felt-tips, metal pen points dipped in India ink are still probably the most common method used for inking cartoons. Metal pen points (also called "crow quills" by Gillot, Hunt, or Speedball) come in a large assortment of sizes and shapes and each point will give you a completely different type of line. Some points create tight, brittle lines, and some allow you to draw fluid, brushlike lines, and others create blunt, thick lines. Go to an art supply store, tell the clerk you'd like a bottle of India ink and one or two each of several

There are several different types of drawing paper you can use for your cartoons. To discover what's right for you, you've got to experiment.

different pen points with holders, then go home and experiment like crazy. Some points will be easy to use, some will frustrate you, but with practice these points can be used to create attractive line work and are definitely worth the effort.

• **Mechanical drawing pens.** Some cartoonists prefer mechanical pens such as Rapidograph because they are as uniform and easy to use as a felt-tip, and they also use dark black, waterproof ink like traditional pen points. Unfortunately, they have a flat tip and are difficult to use at an angle, and they do tend to clog easily and require frequent cleaning. Some cartoonists swear by these pens, others swear at them. Again, you owe it to yourself to investigate this option and experiment.

• **Brushes.** Small artist brushes can be dipped in India ink and used to outline the characters and backgrounds of your cartoons. You can obtain these brushes at an art supply store and, like pen points, they come in a variety of sizes, shapes and widths to experiment with. Learning to ink with a brush requires a lot of practice, but if you really care about the quality of your artwork your patience will pay off.

• **Assorted markers.** A thick black marker will come in handy for large areas of solid black ink. Also investigate some gray markers for shading your magazine cartoons. Gray markers come in many shades and intensities.

• **Colors.** Professionally, you may not yet be ready for color cartoons, since buyers of this work are generally among the elite markets. However, it's never too soon to start learning, so try the following: colored markers, designer gouache, watercolor in a tube, bottled artist dyes, and colored pencils. Ask your supplier about these coloring methods, then try them at home.

• **White paint for corrections and mistakes.** India ink and felt-tip pens do not erase easily, so you'll need some sort of white cover-up for errors. Many cartoonists use white watercolor paint from a tube, but some are getting excellent results with common, fast-drying typewriter correction fluid.

Three different screens were used on this cartoon to add detail and shading to this drawing. Screens are easy and fun to use and come in a wide variety of patterns.

• **Paper.** The type of paper you choose will depend on the type of pen, brush or marker you use and the effect you want to achieve.

For magazine cartoons you'll want to keep your postage costs down by using *typing paper,* which is much lighter than other drawing papers. Go to a stationery store and select a good, high-quality typing paper for best results.

For drawings with colored markers, ask your art supply store for some special *marker paper.* Unlike many other papers, marker paper is made especially for use with markers and will not bleed or dilute the intensity of your colors.

Heavier drawing papers come in large sheets and are more suitable for comic strips and illustrations, where you may have to cut your paper to a special size. Such papers are commonly known as *bristol board, Strathmore board, or illustration board.* These heavyweight drawing papers come in an assortment of thicknesses (1-ply being the thinnest, 2-ply is a bit thicker, etc.) and textures (smooth, rough, very rough, etc.). These papers are excellent for use with metal pen points, brushes and India ink. Again, experimentation is your best teacher.

• **Shading screens.** Shading screens such as those by Zip-A-Tone and Chartpak are sheets of adhesive plastic that can be applied to your drawings to achieve a variety of uniform shading and pattern effects. You will see shading screens used most commonly in newspaper cartoons where other forms of shading do not reproduce clearly on

cheap newsprint paper. Some screens are simple dot patterns which give a solid gray effect, other screens have fancier designs such as flowers and checks that can be used on a character's clothing.

• **Cartoonist furnishings.** If you are serious about cartooning, sooner or later you'll want to get some official cartoonist furniture. If you have room for it, the proper furnishings can make your working hours much more comfortable and efficient. Many stores sell a complete starter set of drawing board, chair and lamp as a package at a fairly low price.

• **Assorted business supplies.** If you begin to sell your work, you'll want to equip your studio with assorted supplies for the business side of cartooning. Primarily you'll need a file for your records, some type of letterhead for correspondence and billing, and a typewriter for professional-looking communications.

As you become more successful, you can add other helpful business tools such as a desk, fax machine, copying machine, phone and answering machine, maybe even a computer. As a beginner, you needn't be too concerned about these things right now, but as you become more successful it will be exciting to see your studio expand and become more and more professional.

A successful cartoonist's studio might include a large drawing board, swivel chair, drawing lamp, supply tables, file cabinets, paper cutter, copying machine, telephone, fax, answering machine, typewriter or computer, and probably a radio or TV to help pass the time during long hours of drawing. And a cat to lie on everything.

• **One piece of furniture you can't live without: a filing cabinet!** You can get a filing cabinet pretty cheap at most department stores; if you can't afford that, you can probably find one at a garage sale. Get one if you can, because it will become one of your most valuable possessions!

Once you've got your filing cabinet, fill it up with dozens or even hundreds of photographs and drawings clipped from magazines and newspapers. These pictures will be your visual reference file. This file will help you draw almost anything you'll ever need to draw!

For example, say you're doing a cartoon about medieval knights in armor, but you're not exactly sure how to draw a knight because you can't remember enough details about the armor's shape and design . . . so you go to your reference file and find a photo or drawing of a knight . . . instantly you've got all the details you need to draw a perfect knight!

To get your file started, collect a bunch of old magazines and clip out anything that seems like it might be a valuable reference one day . . . automobiles, boats, buildings, plants, animals, sports uniforms, foods, racial and ethnic varieties, clothing styles, etc. Next, organize each category in your file so you can find it quickly and easily. Later you might want to cut out other people's cartoons and add them to your files also for guidance and inspiration. As you become more seasoned and confident in your work, you may find yourself referring to this file less and less . . . but you will probably never outgrow need for it entirely.

You don't need anything fancy to get started. You can launch your own cartooning career right at your kitchen table with a pencil, a sheet of typing paper, and a felt-tip pen from the corner drugstore.

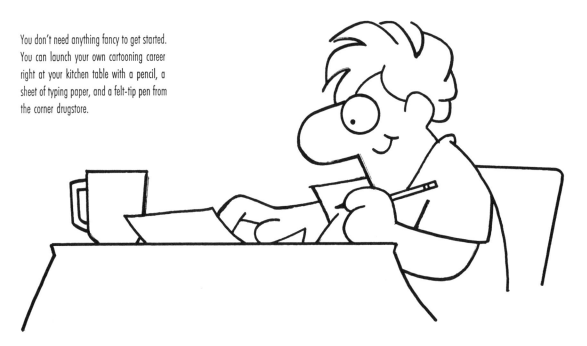

## *Cartoonist Profile:*
# JOHN CALDWELL

TOO BIG FOR HIS BRIDGES

If you recognize the work of John Caldwell, you've probably seen his cartoons in *Mad* magazine . . . or you bought a copy of his wildly successful *Fax This Book* . . . or you used to read his "Caldwell" panel in your daily newspaper . . . or you bought his calendar . . . or you recognize his illustrations from *Writer's Digest* . . . or maybe you've been a reader of great magazines like *Esquire* and *Playboy* . . . or perhaps you've seen his cartoons in humor anthologies such as *The Big Book of Jewish Humor* and National Lampoon's *Cartoons Even We Wouldn't Dare Print.* If you have a good pair of eyes and a sense of humor, chances are you're already familiar with the work of John Caldwell. It's everywhere!

Growing up, John received a lot of attention in school for being "the kid who can draw good" and

was frequently called on by teachers and classmates to do holiday decorations, notebook doodles, and posters for aspiring class presidents. Although he took no art classes in high school, he did receive some training via the Famous Artists Correspondence School. Later, he attended Parsons School of Design in New York City and majored in graphic design. "Although I took no cartooning courses, I feel the many life drawing, painting and three-dimensional composition classes laid a solid foundation for my work today." After art school Caldwell landed a job doing brochure layouts and traveling exhibits for the Department of Transportation. "It was during these five years of civil service that I started cartooning at night and in my spare time. At first I approached it as a way to make a little extra money on the side. But after two years of rejection slips, I made my first few sales and I was hooked."

In the early years of his career, John was influenced by the bizarre and offbeat cartoons of Gahan Wilson, Charles Addams, Sam Gross and Charles Rodrigues. Like many of today's best cartoonists, Caldwell was strongly influenced by the late B. Kliban, best known for his legendary cat book and other anthologies of strange and wildly imaginative cartoons. Caldwell believes that Kliban was responsible for a lot of people breaking away from the norm. "He broke the boundaries of the traditional gag cartoon. When he came on the scene his stuff was not derivative of anything before it. He created a freewheeling approach to gag cartooning that all of us working the odd side of the street must pay homage to. Around 1970 I was selling to a now defunct publication called *Evergreen Review.* One day the editor mistakenly sent back some rejected material in my envelope. It turned out to be a batch of Kliban's cartoons. It was great stuff, most of

which later ended up in *National Lampoon* and in his collections. What struck me, besides the fact that the work was brilliant, was the different sizes of each cartoon. Nothing was the usual 8½ by 11. It appeared he would work with whatever piece of scrap paper that was available. Just another example, I suppose, of his unwillingness to conform to standards."

After nearly two years of rejection, John Caldwell finally made his first cartoon sale in 1970 to a magazine for ten dollars. In the beginning John focused on producing one-panel cartoons for magazines, but has since shifted his focus to other areas including children's book and magazine illustration, a line of greeting cards for golfers, a successful series of faxable cartoon books for Workman Publishing, a daily syndication panel for King Features, calendars, and other assorted creative projects. "I like the idea that the next project is totally different from the one I'm working on now. Trying different things keeps me fresh. At least I hope so."

To many readers, John Caldwell is probably best known as one of *Mad* magazine's "usual gang of idiots." "I first hooked up with *Mad* sometime in the 1970s. It wasn't until a few years later that they assigned me to draw a piece I'd written. One thing that comes to mind when I set out to write a *Mad* piece is that I'm filling up at least one or more full pages. *Mad* doesn't buy spot gags unless you count the brilliant stuff Sergio Aragones does in the margins. So I have to think in terms of volume within the initial concept. Can I come up with enough good individual gags to fill out a spread? As far as illustrating for *Mad*, every so often the editors will assign me to a spread written by someone else. The task here becomes the same as if I were illustrating text for any magazine or book. I try to come up with the best visual to illustrate the author's point.

The main thing I try to avoid in any illustration job is being literal. I try to find a visual hook that compliments the author's words rather than echo precisely what's written. Also, most importantly, the drawing must be funny."

Despite his success, Caldwell believes cartooning is a challenging and often difficult business. "I have periods when money comes in and I go through the lean times, too. I think a lot of people give up because they can't take the rejection that's inherent in this business. No matter how long you do this and how many markets you sell to, you still get the occasional rejection. Sometimes even more than occasionally. Even when an editor buys one out of a batch of ten, that's still a 90 percent rejection rate."

John believes that many hopeful cartoonists have brief careers because "some people just plain run dry. Their abilities aren't up to all they need to do to squeeze out a living. They simply don't have enough ammunition to begin with, or they never figured out how to tap deeper into their creative resources. I still have tough days with self-doubt and writer's block, but what gets me through them is the knowledge that after all these years of cartooning, I'm not trained for anything else. I'll never be an airline pilot or a dance instructor or a florist or an accountant.

"This is a difficult business. Markets seem to be on the dwindle. The economy has booted a few publications out of existence and many others have been forced to cut back. Despite the bleak short-term outlook, cartoonists will still find a way to peddle their wares. It took me close to two years before I sold my first cartoon. By being prolific and persistant the beginner will eventually break through with a first of, hopefully, many sales."

Fortunately, John Caldwell's persistence has paid off. For John . . . and for his fans.

## How to Prepare Your Cartoons for Publication

Once you've gathered together all of your tools, you need to use them effectively so you can start selling your funny ideas and drawings. Cartooning is a great way to earn extra cash at home in your spare time! If you are very good and very ambitious, you might be able to turn your cartooning into a full-time career.

If you've been doing the homework assignments in this book, you've already had some experience sketching your cartoons. Now let's fine-tune your work and make it suitable for prospective editors and publishers.

## How to Sketch and Ink Your Magazine Cartoons, Step by Step:

1. Start with a funny idea and a sheet of 8½ × 11-inch typing paper. Heavyweight typing paper will hold up best in the mail and resist crumbling when handled by several different editors. A twenty- or twenty-five-pound bond paper is recommended.

2. Next you'll need to determine the right characters and setting for your funny idea. Then begin to sketch your cartoon in pencil. Don't be afraid to erase mistakes and make changes until you get the drawing exactly the way you want it. (Some misguided people think that erasing is the sign of a poor artist; they are very wrong.)

Remember to leave plenty of white border space around your drawing so you will have room for your caption on the bottom and so the editor and printer will have room for any necessary notations they may need to make prior to publication.

And don't forget to use your visual reference file to help you draw your characters, clothing, furniture, scenery, etc.

Also, look at other cartoonists' work as you sketch your cartoon. Pay attention to how the pros lay out their panels, the styles they use, the way they use shading and solid black areas, perspective, etc. Allow yourself to be influenced by the good stuff.

3. After the drawing is pencilled exactly the way you want it, it's time to trace over your pencil lines with black ink. Black ink is necessary so your drawing will photograph and reproduce clearly for publication. Remember to ink both your characters and your background details.

If you make a mistake with ink, brush white watercolor paint from a tube or some typing correction fluid over the error (make sure the ink is dry first!) and then re-ink the area if necessary. For major inking errors, it's best to start over from scratch. (Major goofs will happen less and less as you become more proficient with your inking tools.)

After you've finished inking and the

Begin sketching your cartoon in pencil. Don't be afraid to use your eraser to make changes until your drawing is exactly the way you want it.

After the pencil sketch is exactly the way you want it, trace over your pencil lines with black ink. After the ink is dry, gently erase any pencil lines that remain visible.

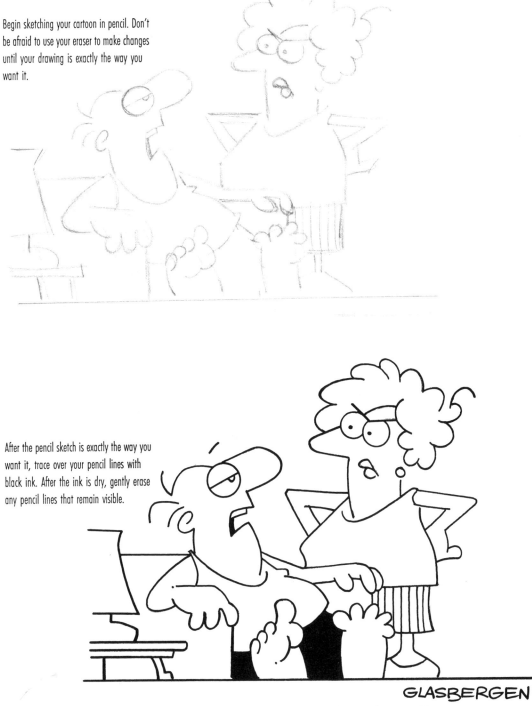

GLASBERGEN

*"Of course I still love you! I'm too tired to hate you!"*

```
Joe Cartoonist
PO Box 1000
Inkville, NY
Phone: 607-555-1234

#592-AB
```

ink is completely dry, gently erase any pencil lines that remain visible on your inked drawing.

If you wish, you may embellish your finished drawing with gray shading. You can achieve shading by using gray markers, shading screen, or by brushing on ink diluted with water. Shading is not mandatory; some cartoonists thrive on shading and many use none at all. Shading is a matter of personal taste and choice.

Next, type or print your caption underneath your finished drawing. Make sure your caption is neat, concise and free of spelling errors. Don't forget to sign your name to your work!

4. Finally, turn your cartoon over and type, print or rubber-stamp your name, address and phone number on the *back* of your cartoon. When you mail your cartoons to a publication, this will tell the editor where to contact you if you've made a sale. This is a very, very important step that must not be forgotten.

Also, put some sort of identification number on the back of your cartoon. Identifying your cartoons by number will make it easier for you to keep track of them when they are in the mail. Use a notebook to record your cartoon I.D. numbers and the magazines you've mailed them to.

In the next chapter, you'll learn where and how to mail your magazine cartoons and how to get started selling your freelance cartoons.

## How to Sketch and Ink Your Comic Strips, Step by Step:

1. Select a drawing paper you are comfortable with and cut out a piece large enough for your comic strip drawing. Your comic strip drawing should be approximately two or three times larger than the comics you see printed in your newspaper. For example, if the comics in your newspaper measure 1¾ × 6¼ inches, then you should draw your comic strip two or three times larger. (That would be 3½ × 12½ inches or 5¼ × 18¾ inches.)

Review your funny idea and plan how many boxes you'll need to communicate your gag. Generally, standard formats permit two, three or four panels per strip or sometimes just one long single panel. Using a pencil and ruler, lay out your boxes and borders.

Next, use a ruler or straight edge to pencil in guidelines for your lettering. These guidelines will help you keep your lettering straight, neat and well-spaced.

2. Once your preliminary layout is complete, go ahead and pencil in your characters' words and dialogue.

Now pencil in your characters and backgrounds. Keep your panels uncluttered and easy to read. Look at the comic strips in your newspaper for ideas on how to improve the look of your own strips. Remember that most people read from left to right, so the first character speaking should be on the left and the second character to speak should be on the right. Much of your layout savvy will come with simple common sense and a bit of experience. (As always, the more you practice, the better you'll get.)

3. Using whatever pen looks and feels best for your style, carefully ink in your lettering and speech balloons. Then ink your characters, backgrounds and borders.

As you ink your comic strip, remember to use large areas of solid black to direct your reader's eye to important details and to make your strip really stand out on a page. Without this detail your comic strip may end up looking more like a coloring book page.

If you make any inking mistakes, wait for the ink to dry then correct the errors using the correction methods discussed earlier.

After your ink is completely dry, carefully and gently erase all remaining pencil lines.

Add shading screen, if desired. Do not use gray markers or wash on comic strips. For comic strips printed on newsprint, shading screen is the only generally accepted form of gray shading.

Don't forget your signature . . . you've worked hard and you deserve a little recognition!

In the next chapter you'll find more information on how to submit and sell your comic strips to your local newspaper or major newspaper syndication company.

First, lay out your boxes and borders. Use a
ruler or straight edge to pencil in guidelines
for your lettering.

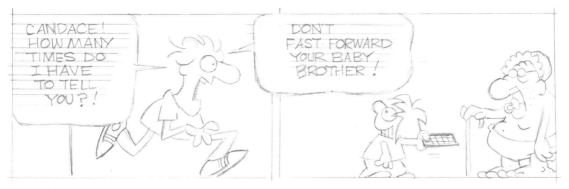

Next pencil in your characters and
backgrounds.

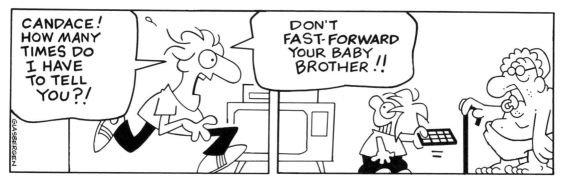

Finally, ink in your lettering and speech
balloons carefully, then ink your characters,
backgrounds and borders.

## This Is Only the Beginning . . .

Magazine cartoons and comic strips are by no means the only form of cartooning you should be exploring! Although these are the two simplest formats for getting started in your own home, don't rule out greeting cards, animation, comic books, advertising, calendars, editorial illustraion, corporate cartooning, and other creative avenues for cartooning. Some forms of cartooning may require special training in animation or graphic arts. Other forms are best achieved with an art education combined with personal on-the-job experience. In some cases, you will need more education and technical training than can be provided in a simple step-by-step instruction book. If you have the opportunity, a solid commercial art education can be valuable and is strongly recommended.

Use this book as a starting point. Once you've mastered the tools you've learned about in this chapter, you'll be ready for new challenges. The skills you'll learn while practicing magazine cartoons and comic strips are transferable to all kinds of other cartooning jobs. When you're ready to branch out, start investigating different forms of cartooning. If you are especially clever and resourceful, you may be able to acquire plenty of on-the-job training as a freelancer, picking up a wide variety of jobs as your name and reputation become established . . . so keep your eyes and ears open for exciting new opportunities!

In the next chapter you'll learn more about your cartooning career opportunities, but until then . . .

### Bigg's Business

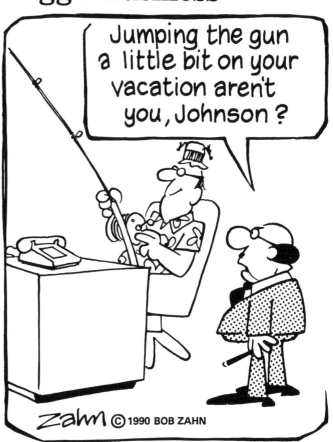

Jumping the gun a little bit on your vacation aren't you, Johnson?

Zahn © 1990 BOB ZAHN

## Don't Forget to Practice Your Lettering!

Comic strip lettering is a very important skill to learn and freelancer Bob Zahn is one of the best at it. The samples of Zahn's work on these pages show three very different styles of quality comic strip lettering. Notice how each style of lettering affects the mood of the characters and the overall appearance of the cartoon.

Your lettering should always be neat and easy to read. Learning how to do great lettering takes a great deal of practice and, frankly, it's not a lot of fun. But as these comics prove, great lettering can really enhance your artwork!

Bob Zahn has had three comic strips syndicated during his freelance career: "Bigg's Business," "McCobber" and "Hap Hazard" have appeared in more than a hundred newspapers.

## Hap Hazard

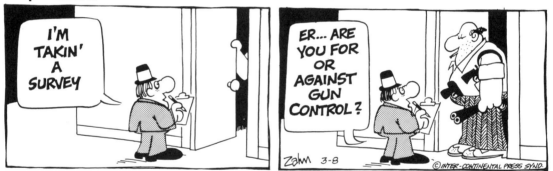

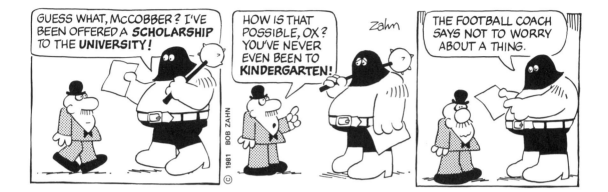

## Homework

❶ Obtain as many cartooning tools and supplies as you can comfortably afford. Bring them home and play with them. Get acquainted with a variety of different pen points and papers and screens. Become comfortable with them.

❷ Start clipping magazine photos for your visual reference file. Start tonight while you watch television . . . it's healthier than eating potato chips!

❸ Draw ten funny magazine cartoons (ten to twenty is typical for a professional submission) that you think are good enough to mail to an editor. Use the tools and step-by-step methods outlined in this chapter.

❹ Create a cast of characters and create eighteen comic strips (three weeks' worth of daily strips) that you think are good enough to mail to an editor. Again, use the tools and step-by-step methods outlined earlier in this chapter.

   Yes, ten magazine cartoons and eighteen comic strips are a big assignment! So take your time, enjoy the process and do a great job! You're learning how to be a cartoon factory. If you become successful, you will be doing *thousands* of magazine cartoons or comic strips . . . so don't allow yourself to be intimidated by an assignment of twenty-eight cartoons!

## Cartoonist Profile:
# BOB VOJTKO

*"I hope you can help me. I have an earning disorder."*

**B**ob Vojtko (pronouced Voit-ko) knows how to "make big money at home in his spare time." By day Vojtko works for a large grocery store in Ohio, but on nights and weekends he enjoys a second career as a successful freelance cartoonist.

His magazine cartoons are seen frequently in *National Enquirer, Woman's World, First, Good*

*Housekeeping,* and many other popular magazines. For a short time he also illustrated the nationally syndicated comic strip "John Darling" (formerly distributed by News America Syndicate). Bob has a funny, friendly and modern style that is popular with editors and readers. He also has one of the most original and unusual styles in the business.

Bob loves to create cartoons, but also enjoys the security of his daytime supermarket job. Stocking shelves and bagging groceries pays the bills in the Vojtko household and gives Bob enough peace of mind to sleep well at night. His day job allows him the freedom to enjoy cartooning on nights and weekends, without the worry that can come with a full-time freelance career. Although Bob cartoons on a part-time basis, he is dedicated to his craft and devotes a tremendous amount of time and effort to his freelancing.

Handling two busy careers can be tiring and demanding for anyone, but experience has taught Vojtko how to handle the stresses of a dual career. "The only deadlines I have with my magazine cartooning are my own. If I run out of Classic Coke, Chips Ahoy cookies and vitamins and I am just too tired to draw, I can take whatever time off I need to recuperate. But, if I want to get a lot of cartooning done one week, I can always ask for that extra day off from the grocery store."

Bob explains that working two jobs is a careful balancing act, but the rewards are definitely worth the effort. "Working full-time cartooning and full-time in a grecery store does take a lot of energy and wisely planning my time so that I can sneak off to relax. Sometimes I take my cartooning to work and do some on my lunch hour. I also try to spend a few hours after work to write or draw. Some nights I just can't do anything but relax. This builds up enough energy for me to get right back to it the next day. It also helps that I love doing cartoons. For me, drawing is a way to relax, to have fun. I 'work' at the grocery job. I'm relaxing when I draw cartoons. When I get home from the store and open my mailbox, it's like 'trick or treat.' I never know when there will be a nice-sized check in there. This gives me the extra boost I need to get back to the drawing table. On the other hand, rejections also give me

that extra boost because they make me even more determined to sell more cartoons."

Like many freelance cartoonists, Bob receives a helping hand from his wife. "I'm very lucky to have my wife, Sue, by my side because she enjoys cartooning as much as I do. She understands the amount of time it takes to get my cartooning done. Sue is also there to make sure that I do take off enough time to relax. To both of us, cartooning isn't our hobby, it's our career." But Sue is not just a cheerleader on the sidelines, she also helps Bob write and select funny ideas and assists him with the enormous task of mailing and marketing an inventory of hundreds of cartoons.

Vojtko has had no formal art training and believes that cartooning is a talent that can be self-taught by anyone who has enough drive and persistence. He says, "The best kind of education for anyone interested in cartooning is to read as many books on cartooning as you can. My advice for the beginning cartoonist is to really study this book and others about cartooning. Learn the mechanics. Find out how successful cartoonists go about marketing their work. You'll know when you've reached your own drawing style when you feel comfortable drawing, and you can't compare your work to any other cartoonist's. If you've studied other cartoonists, but are frustrated that your work doesn't look like theirs, congratulations! You've found a style all your own. And don't be afraid to change or improve your style as time goes on. I'm never satisfied with my own work. I'm always trying to improve."

While only a few elite cartoonists live in a world of swimming pools and limousines, Bob Vojtko is a great example of how anyone can develop and use a natural talent to earn plenty of extra cash and improve the quality of his life. Bob is not only a terrific cartoonist, but an excellent role model for aspiring cartoonists as well.

After practicing your drawings and perfecting your ideas, you're finally ready to sell your cartoons and get on the road to fame and fortune! Like some cartoonists, you may not sell much right away. Many of today's pros report dry periods of a year or more before they made their first sale, others have hit a bull's-eye their very first try and there are some aspiring cartoonists who will never succeed for one reason or another.

How quickly you begin selling your work depends on many factors: your talent, your goals and ambition, your perseverance, your business savvy, the amount of hours and effort you put into it, and even plain old luck. Most important, you've got to work, work, work, work, work. Remember, if you want to *sell* a lot of work, you've got to *produce* a lot of work!

TIMMY'S
LEMINADE 5¢
AND CARTOONS

Goal setting is a valuable part of your cartooning career! It only takes a few minutes, but the results can last a lifetime.

## First Set Your Goals

Don't start traveling toward success until you've taken time to establish your destination and map out your trip!

When setting your cartooning career goals, ask yourself the following questions:

- Where do I want to sell my work?
- What kind of cartooning best suits my talents and interests?
- Will I need any special education or technical training?
- Do I want the security of a salaried creative position or am I more interested in the freedom of being my own boss with my own studio?
- Do I want to shoot for the big-money possibilities of comic strip syndication . . . or do I prefer the excitement, freedom and diversity of freelance work?
- Do I want a full-time cartooning career or is it something I'd rather do as a profitable hobby?
- How much money do I want to make from cartooning and how would I like to spend that money?
- If I want to quit my current job and make cartooning my full-time career, what must I do to achieve that goal and how much money must I earn from cartooning to make that dream a reality?
- How many hours a week must I spend on cartooning to reach my goals?
- Is my work good enough to sell yet? If not, what can I do to improve it?
- What would I like to achieve a year from now? Five years from now? Ten years from now? Twenty years from now?

## What Are the Career Opportunities for Cartooning?

### Magazine Cartoons

Magazine cartoons are one of the most common ways for a cartoonist to break into the professional ranks. This type of cartoon can be done in your own home and sold to *National Enquirer, Good Housekeeping, Woman's World, Better Homes and Gardens, Prevention, Field &* *Stream,* the *New Yorker, Saturday Evening Post,* and dozens of other magazines all over the world. A small trade magazine may pay as little as five dollars for a cartoon, while larger magazines pay anywhere from seventy-five dollars to five hundred dollars per cartoon.

In an earlier chapter you learned a step-by-step method for creating your own magazine cartoons. Now you're ready to put them in the mail and become a full-fledged freelance cartoonist.

Joe Kohl of Toms River, New Jersey, sold this cartoon to *First* magazine for $125. If you're good enough to sell a few cartoons every week, you can earn a comfortable living from magazine cartoons like Kohl has since 1972. Joe Kohl also does cartoons and humorous illustrations for greeting cards, advertising, T-shirts and children's books.

"No calories, no cholesterol, no sodium, high fiber, and we spiced it up so you'd never know it was sawdust!!"

Tips for selling magazine cartoons:

1. Mail your cartoons flat in a $9 \times 12$-inch manila envelope and enclose a self-addressed, stamped envelope (SASE) for the return of any unpurchased cartoons. Make sure your return envelope has enough postage. Enclose no less than six and no more than twenty cartoons per mailing.

2. Address your package to: Cartoon Editor % the magazine. You can find the address inside the magazine. Make sure you send your cartoons only to magazines that already buy and publish cartoons. For a comprehensive list of magazines that buy gag panel cartoons, subscribe to the *Gag Re-Cap* (mentioned earlier in this book) or purchase the latest edition of *Artist's Market* or *Humor and Cartoon Markets* (both of these directories are published by Writer's Digest Books, 1507 Dana Avenue, Cincinnati, Ohio 45207 and can be found in most bookstores).

3. After you drop your envelope of cartoons into the mailbox, forget about them and start working on your second batch of cartoons. It will probably take about two to twelve weeks for your first batch to come back to you. It may come back with notification of a sale or it may come back with a rejection form.

4. Most important, be a professional. While you're waiting for a response to your batch of cartoons, never never never call up the editor and pester him in any way whatsoever. No editor has time to listen to an overeager cartoonist ask questions like "Didja like my stuff? Are you gonna buy any? Why not? What's wrong with 'em? Don'tcha know

funny when you see it? My mother loved 'em and she's got a great sense of humor! Blah, blah, blah!" Do not contact an editor unless it is truly necessary and if you must call or write, briefly state your business in a courteous and professional manner. Remember, cartooning is a business and you must behave in a businesslike manner at all times.

5. As a beginner, try getting started with smaller magazines that pay less. The competition will be far less severe, and your odds of making a sale or two will be much greater. Gradually, you can begin to climb the ladder to bigger and better markets, as you gain experience and confidence.

Compared to other formats, magazine cartooning is a fairly easy way to enter the business and obtain professional status. From this point a skilled and ambitious cartoonist can begin to branch out into other types of cartooning.

## Comic Strips and Syndication

If magazine cartoons are the easiest way to break into the professional ranks, comic strips may be the hardest. A good comic strip or panel will run in newspapers for ten, twenty, thirty years or more. It takes a very special talent and cast of characters to achieve this kind of success and longevity.

Don't make the mistake of assuming that all comic strip artists are wealthy. While a few of the most elite comic strips earn their creators millions of dollars annually, this is unusual. Although most successful comic strips earn their creators a better-than-average living,

Comic strips are one of the most popular and lucrative forms of cartooning. Syndicated cartoonists have the financial security of a monthly royalty check, get to work wherever they want and set their own hours, and enjoy the satisfaction of having their work seen by millions of readers every day.

there are many comic strips running in newspapers that earn far less.

Every newspaper that buys a particular comic strip or panel pays a weekly fee to the company that distributes the feature. This company is known as a "syndicate." The syndicate sells the comics to the newspaper editors, mails copies to client newspapers each week, and collects the payments, which it splits contractually with the creator. The most common financial arrangement is a fifty-fifty split between the syndicate and creator. The more newspapers that carry your comic, the more money you earn. The size of the newspaper is also

a factor, with successful big city papers paying more than the smaller hometown news.

A comic strip or panel with a few small papers may earn its creator less than $500 a month. A more successful feature could earn you $15,000 annually or $150,000 annually or $300,000 annually . . . or more! There is no way to predict how successful or profitable your comic strip will become. ("Peanuts" and "Beetle Bailey," two of the most successful features of all time, were nearly killed off in their infancy because too few papers were buying them and their syndicates considered them failures!)

## Tips on Getting Your Comic Strip Syndicated

1. Create your cast of characters, write your gag ideas and draw up at least eighteen finished samples. When drawing your strips, remember to use the guidelines offered earlier in this book.

2. Draw up an introduction sheet with a sketch of each cast member and a brief description of each character. This will introduce the editor to your strip and tell him what it is about.

3. Take your strips to a local copy center and have each strip reduced and photocopied.

4. Mail copies of your strip to the syndicates. Do not mail the original artwork. (A complete listing of large and small syndicates can be found in *Artist's Market* and in *Humor and Cartoon Markets*.) Include a self-addressed, stamped envelope for the syndicate's reply.

5. Pray for success. Buy a good luck charm. Toss some salt over your shoulder. Throw lots of pennies into lots of fountains. Knock on wood, plastic, Formica or any other lucky surface.

6. If at first you don't succeed, try, try again. Many successful syndicated cartoonists have tried several features before hitting upon a successful formula.

7. If you do succeed, you will get a contract from a syndicate. Be sure to negotiate terms you can live with . . . success is no fun if it makes you miserable!

A successful humorous illustrator must be more than just a good artist. He must also be a clever and energetic businessman and a master of self-promotion. He should also have good phone skills and be comfortable talking with clients.

## Cartoonist Profile:
# TOM CHENEY

*"Buy the car, or I'll kill you."*

Since his first cartoon sale to *Easyriders* magazine in 1977, Tom Cheney has been one of the most successful, popular and dynamic freelance cartoonists in the business. Thousands of his cartoons have appeared in the *New Yorker*, *National Lampoon*, *Mad* magazine, *Omni*, *Cosmopolitan*, *Punch*, *New Woman*, *Woman's World*, *Esquire*, *The Wall Street Journal* and more than 400 other publications worldwide. In 1985 he won the Scripps-Howard Outstanding Cartoonist Award.

Among his peers, Cheney is known to be one of the most clever and funniest challengers in the field.

Tom Cheney was not born great, but grew up with an obsession for drawing. Cheney took several drawing and painting courses in college, but majored in psychology. Tom believes that his education in human behavior, combined with his artistic training, was perfect for an aspiring cartoonist. These days Tom earns a good living by

drawing funny pictures about odd human behavior.

Cheney made his first attempt at professional cartooning at twenty-two, doing cartoons during the week and working at various "crummy" jobs on weekends. It took nearly a full year of rejections before Tom received his first letter of acceptance for a cartoon.

Tom lists famous cartoonists Sam Gross and Charles Rodrigues among his major influences. Like Gross and Rodrigues, Cheney has a reputation for doing highly original cartoons that go a step beyond the ordinary. "Regardless of the magazine I'm targeting," says Cheney, "I always try to keep my thought process 'way out,' while considering the editorial limits of the magazine. I've always had a lot of success by working for one publication per day. It helps me focus my thinking. The editors I've worked with appreciate that, and they know I'm always ready to give them an exclusive effort instead of just pulling spares out of my file cabinet. I've acquired some very loyal clients with that approach."

Cheney has some clear opinions about the business of cartooning: "I think of myself as an artist more than a businessman, simply because the artistic pursuit of cartooning is much more time-consuming than the business end. I've always found that when I concentrate too much on the rigors of selling, marketing, researching, etc., that the quality of my work begins to suffer from a lack of attention. The older I get, the more of an artist I become. Given the small lozenge of time we have on this earth, I would rather look back on a lifetime of artistic achievement than decades of hustling. I find that when my work is at its best, I have no problem finding someone to publish it."

Another reason Tom Cheney has been so successful is because he understands the value of having a great gag as the foundation for every cartoon. "I've always given a great deal of attention to my gag writing, and I suspect that's where most beginning cartoonists get stalled or fail completely. I've never been able to sell a lousy idea, not even with the most flourishing display of draftsmanship, but I've had hastily drawn roughs purchased 'as is' simply because they were hung on a dynamite concept." Despite his success at creating funny ideas for many years, Tom admits that he still has no clear idea of where exactly all those ideas come from. "It's still a mystery to me," he confesses.

To the aspiring cartoonist reading this book, Tom Cheney advises the following: "First and foremost, get all of the education you can afford. Professional cartooning is going to place a heavy demand on everything you've learned and experienced. Learn to write ideas just as diligently as you develop your drawing style. Keep in mind you're entering a field where at least a hundred seasoned, talented professionals are producing brilliant pieces of work on a daily basis. It takes practice, patience, persistence . . . and postage."

As a leader in the field of magazine cartooning, Tom Cheney's ongoing practice, patience, persistence and postage continue to bring him new fans and new dollars every day.

## Freelance Humorous Illustration

Humorous illustration is a form of cartooning where you are essentially working as a hired hand, creating cartoon art on assignment for an editor or art director who is familiar with your drawing style. In this type of cartooning, an art director will call you because he enjoys your style and feels it will enhance the look of his page or product.

A good humorous illustrator can find freelance work in advertising, book publishing, magazines, newspapers, animation, greeting cards, audio-visual presentations, record albums, children's books, and many other formats and media. Fees paid for humorous illustration will vary tremendously, depending on the type of work, size of the client and reputation of the cartoonist. A newcomer may earn twenty-five dollars for a small, black-and-white newspaper illustration and a successful pro may earn several *thousand* dollars for a single full-color advertising cartoon!

To receive humorous illustration assignments, you'll need to do the following:

1. Advertise and promote your services. Design a promotional flyer or postcard to advertise your work to prospective clients. A simple black-and-white flyer or brochure is the easiest and least expensive way to begin. Later you can invest in a more expensive mailer that shows your work in full color. Well-established humorous ilustrators often spend thousands of dollars per year to advertise their services with mass mailings and advertising pages in large talent directories such as *The Creative Black Book* and *American Showcase*.

2. Mail your postcard, flyer or brochure to many potential clients. You should mail your samples to advertising agencies, greeting card companies, magazines, book publishers and anyone who might be able to employ your services. At first the cost of postage may only allow you to mail a hundred or so pieces, but you can increase the volume of your mailings as you begin to increase your promotional budget. Again, *Artist's Market* and *Humor and Cartoon Markets* are your easiest sources of names and addresses of potential buyers.

3. Check your Yellow Pages for local companies that might be able to use your illustrations. Put together a professional-looking portfolio of your work and make appointments to show your samples in person. Use these opportunities to network, gathering tips and making important local contacts.

4. When you begin receiving assignments, always be sure to behave in a courteous and professional manner. Never miss a deadline and remember that the customer is always right. Whenever possible, go the extra mile to give your customer a little more than he expects . . . if he asks for two preliminary sketches to choose from, give him three; if he wants his work on Thursday, try to deliver by Wednesday; etc. If your client has enjoyed a good experience working with you, he is more apt to call you a second time.

5. Never sit back and rest on your laurels. To receive a steady flow of assign-

ments, you'll need to constantly promote yourself and attract new work. As a freelancer, you're only as successful as your last job. Today's job will pay this month's bills, but you'll need to hustle more work if you want to pay next month's bills. Keep mailing your promotional pieces on a scheduled basis, whether it is once a month or four times a year, but do keep your name and style in front of your clients if you want to work and eat regularly.

## Greeting Cards

Greeting card publishers use an enormous amount of cartoon art and offer great opportunities for both the staff and freelance cartoonist. These companies employ hundreds of artists and cartoonists to create thousands of new cards every year, plus a huge assortment of T-shirts, calendars, coffee mugs, gift wrap, books, and specialty items.

If you want to draw greeting cards, you'll need a solid understanding and mastery of design, composition and color. Although many of today's greeting cards have an amateurish look about them, that look is deliberate and was not created by amateurs. If you are serious about creating greeting cards as a career, you should seriously consider a solid formal art education.

To obtain a staff job with a greeting card company, you should make an appointment with the Director of Creative Recruitment to show your portfolio, learn more about the company and dis-

If you have a distinctive and popular style, you can create greeting card art from your home studio. If you're looking for a steady paycheck and a creative working atmosphere, you might want to seek full-time employment with Hallmark Cards, American Greetings, Gibson Greetings or any other large greeting card company. Remember, if you can write ideas as well as draw them, you'll be *twice* as valuable to an employer or client!

cuss employment possibilities. Staff salaries and benefits vary from employer to employer. Chances are you won't get rich as a staff artist for a card company, but you will enjoy working in a highly creative atmosphere surrounded by other artists and zany people like yourself.

As a freelancer interested in greeting cards, you can show your portfolio by mail or send a full-color flyer to advertise your cartooning services. If you receive an assignment from a greeting card art director you can expect to earn between seventy-five dollars and five hundred dollars for your drawing, depending upon the size of the company and the complexity of the assignment.

If you can write funny greeting card verses as well as you illustrate them, you may be able to sell the complete package to a card company. If your ideas and art are especially good, you may be able to sign a contract for an entire line of ten, twenty, thirty or more cards and receive royalties on each card sold.

Before diving into the greeting card business, study the work you see for sale in the stores. Go to several card shops to study the work of different companies. Invest a few dollars and buy a pile of cards to bring home to study further. Learn how to be an expert at using colors: go to art school, take an evening art class, or read some books on the subject and practice at home.

You can find an extensive list of greeting card companies (including their addresses, phone numbers and key personnel) in the latest edition of *Artist's Market* or *Humor and Cartoon Markets*.

## Children's Books

A good humorous illustrator can obtain work in children's books, although many publishers seem to prefer work that is more "illustrative" and not too "cartoony." The basic method for getting this kind of work is pretty simple: Include several publishers in your humorous illustration promotional mailings; if an art director is interested in your work, you'll probably be asked to send a more complete portfolio of your samples; if you are hired to illustrate a book, you will be sent a contract of terms to review and sign. A solid graphic art education can be very helpful here, since you may be expected to have some professional understanding of layouts, color separations and other skills.

## Newspapers

Many large city newspapers employ a sharp-witted and versatile cartoonist on staff. This cartoonist is responsible for creating an editorial or political cartoon every day and will often be called upon to create humorous illustrations for special sections and Sunday magazine pages. If a staff cartoonist is especially talented, his editorial and political cartoons may be picked up by a large syndicate and sold to other newspapers nationwide.

A good newspaper staff cartoonist

Can cartoonists do good children's books? Of course! Dr. Seuss was an excellent cartoonist and probably the most successful children's book creator of all time.

must have a razor-sharp wit and be able to analyze local and world events humorously. He must also have the ability to draw swiftly to meet his daily deadlines.

Unfortunately, most newspapers only need one cartoonist on staff, so career opportunities are relatively few and rare. If you want to work for a newspaper, your best approach might be to create your own editorial and political cartoon samples and send them to several newspapers as a form of audition. You may also find it helpful to first find work with a small newspaper and use that as a stepping-stone to bigger and better career opportunities.

If you're still in school, you can gain some newspaper experience by doing cartoons for your high school or college newspaper. You may also find that a solid journalism or political science education is great training for a career as a newspaper staff cartoonist.

You would also be wise to write to your favorite political cartoonists. Ask them how they got into the field. Solicit their advice. Make them your role models and learn from their experience.

As a freelancer, you can find newspaper work doing humorous illustration assignments for special articles and Sunday magazine sections. To obtain this type of work, be sure to include several major newspapers in your promo-

A good editorial/political cartoonist must keep up on world events and have a sharp mind.

You don't need super powers to draw comic books, but super talent and super ambition wouldn't hurt!

tional mailings.

Occasionally newspapers will publish a comic strip series created by a talented local cartoonist. If you are unable to get your comic strip syndicated, show it to your newspaper editor and try to get him interested in publishing it locally. This won't make you rich, but it can be a great way to gain some valuable experience and reader feedback.

## Comic Books

Again, the best way to get work is to show your best work to your prospective client. Pencil and ink some sample comic book pages and let this be your audition. Send photocopies of your pages, not original artwork (which may be damaged in the mail). Put your samples in the mail with an SASE and hope for success.

A comic book cartoonist must be an excellent artist and be able to meet deadlines reliably. Check your favorite bookstore for detailed how-to books on this cartooning specialty.

Payment for most comic books is generally on a per-page basis and will vary according to your project and reputation.

## Cartoonist Profile:
# BRUCE COCHRAN

COCHRAN!

"IF WE PROMISE TO ENJOY NATURE ALL DAY CAN WE GO INTO TOWN AND PLAY VIDEO GAMES TONIGHT?"

**B**ruce Cochran has been one of America's most successful and well-known gag cartoonists for more than three decades. Throughout the sixties, seventies and into the mid-eighties, Cochran's gently risqué cartoons were a regular fixture in *Playboy* magazine. For nearly ten years his popular sports cartoons appeared every day in *USA Today*. Bruce has also been both a writer and an illustrator for Hallmark Cards, working under contract since 1962.

Even as a very young child, Bruce Cochran knew he was destined to become a professional cartoonist. His mother and sister were both artists and his home was filled with a wide assortment of popular weekly magazines (*Colliers, Saturday Evening Post*, etc.), each containing as

many as fifteen to twenty-five gag cartoons per issue. Bruce surrounded himself with these cartoons by cutting them out and plastering them all over his bedroom walls. In high school, Bruce took several art classes and later went on to receive a BA in design from Oklahoma University in 1960.

After graduation, Bruce took a job as an artist with Hallmark Cards in Kansas City. At this time he also began submitting his first cartoons to a few popular magazines. Although most cartoonists struggle for many months before selling their first cartoon, Bruce sold a cartoon from his very first batch . . . to *Playboy*, one of the very best-paying and most prestigious markets in the business. Soon he was selling his cartoons to all of the top magazines and decided to leave his job at Hallmark to freelance full-time. Hallmark maintained their relationship with Cochran by putting his talents under contract; a contract that has been the foundation of his career ever since, allowing him the freedom to freelance while retaining some degree of financial certainty.

Later, as a featured sports cartoonist for *USA Today*, Cochran's work was seen on a daily basis by millions of readers. "The only real perk I had," says Bruce, "was that I could take the cost of attending sporting events off as a legitimate business expense at tax time. When I was hired, something was said about sending me to things like the Superbowl and the World Series to send cartoons back every day, but they never did it." Due to cuts in the publisher's budget, *USA Today* stopped publishing cartoons in November, 1991 — an unfortunate event for both Cochran and his legion of fans.

Bruce is discouraged by the diminishing number of magazines using gag cartoons and cautions the aspiring cartoonist not to specialize only in this one format. He recommends creating work for a variety of buyers (magazines, greeting cards, advertising, etc.) and encourages the beginner to try applying his sense of humor to some nonvisual markets also, such as TV writing, stand-up comedy, and writing for comedians. He believes that variety, combined with frugality, is the best way to earn a living in today's challenging marketplace.

Like any good cartoonist, Cochran considers himself to be both an artist and a writer. To create his funny ideas, he keeps a notebook handy most of the time and jots down subject matter as it comes to him. "These are mostly just subjects about which I might be able to draw a cartoon," he says, "rather than a full-blown cartoon idea. Then, when it's time to go to work, I'm not sitting there picking dog hair off my socks and staring at this frighteningly blank piece of white paper. I write best in the morning, only do it about two hours, maximum, and try not to write for the same markets two days in a row. When I'm out, I like to keep a tape recorder or notepad handy because I get lots of ideas when I'm not actually trying to think of them. I even get ideas while I'm sound asleep at night that are often surprisingly good. Other times they're totally useless!"

Cochran is also an avid outdoorsman and this passion has found a place in many of his recent cartoons. His deer hunting cartoon book, *Buck Fever* (Willow Creek Press) sold out in only five weeks and quickly went into a second printing. The success of *Buck Fever* has lead to a series of spin-offs, including *Bass Fever*, *Duck Fever* and *Trout Fever*.

And it all happened because years ago Bruce Cochran caught a case of Cartoon Fever!

## Animation

Animation studios employ hundreds of artists to create moving cartoons for television programs, commercials and theatrical films. To be an animation cartoonist, you'd certanly benefit from an art education and some training in animation and film. If you are interested in entering this field, try to find a training program that will give you the expertise you need. It would also serve you well to contact some animation studios and learn as much as you can about the business and its career opportunities.

As a freelancer, remember to include large and small animation companies in your promotional mailings. If an art director likes your style, he may hire you to create storyboards and character design.

Several animation studios are listed in *Humor and Cartoon Markets* and *Artist's Market*.

## The Local Market

Even in a small town, an ambitious beginner can find work doing cartoons for local businesses, ads, publications and advertising circulars. You might also consider doing cartoons and caricatures for schools, churches, civic organizations, fire departments and clubs.

If you live in a small city or town, you may have no competition and cartooning jobs may be fairly easy to obtain. Getting work in the local market is not much different from attracting clients from other cities: First print up samples of your work, then show them to as many potential customers as possible and wait for the phone to ring. Or you may have more success delivering your samples and making your contacts in person. Regardless of your approach, remember to present yourself as a friendly and cooperative businessperson who the client would enjoy working with. Even in a

If you dream of seeing your drawings jump to life on the television or movie screen, animation might be the cartooning career for you!

ANIMATION CAN BE A MOVING EXPERIENCE

An ambitious cartoonist can find work anywhere!

*"It was a good day at the office. Everybody played nice and nobody had to stand in the corner."*

small marketplace, you should conduct yourself as professionally as you would in any major city.

A small business may not be willing or able to pay you a lot of money for a local newspaper advertising cartoon, but this should not discourage you from taking the job. In the early stages of your cartooning career, the important thing is to gain experience and confidence in as many ways as possible.

Many small cities and towns have at least one large business or factory that employs a lot of people. Be sure to put this company on your list of places to visit. If someone in authority likes you and your work you may be hired to create cartoons for a company brochure or newsletter, slide presentation, trade advertisement or maybe the boss's annual holiday card. A cartoon or series of cartoons for this type of local company may earn your $25, $50, $100, $250 or more. This is certainly a market worth investigating, so don't be shy!

## A Final Word About Cartooning Careers

*Remember, whatever you make of your career is up to nobody but YOU! No one ever became a success by sitting at home waiting to be "discovered."* Take responsibility for your own success . . . don't rely on your family or your friends to make your connections or talk to your customers. Don't expect the world to beat a path to your door just because you've had a few cartoons published. Although unexpected career opportunities do come along once in a while, most doors don't open for you until you knock on them. Whatever career path you choose to follow, do it aggressively. Don't wait for good things to happen — get out there and make them happen!

## Stay Optimistic

At times it may seem like nothing is happening with your career . . . but remember that sometimes success isn't easy to see right away. While you're sitting at home feeling depressed about slow sales, an editor in New York City might be flipping over a batch of your cartoons. You may be very successful and not know it yet! So never throw in the towel.

GLASBERGEN

## Homework

❶ Get your career in motion. Do something *today* to get your work published. Mail off a batch of ten magazine cartoons. Submit a comic strip to a syndicate. Create a dozen card ideas and sketches and mail them to a greeting card company. Make an appointment with the art director or editor of your local newspaper and explore these cartooning career options. Get a flyer of samples printed up and mail them to potential buyers. Take some action today and get going!

❷ Visit your local bookstores and libraries. Seek out other books that can help you become skilled in various cartooning specialties (comic books, animation, graphics, greeting cards, silk screen for T-shirts, etc.).

❸ Take some time to establish your cartooning goals. Decide what you want to get from your efforts, then put it in writing and post it above your drawing board. (Your written goals will not only inspire you, but they will also keep you moving in the right direction and prevent you from veering off course into activities that may not produce the results you want.)

*Peter broke all records in the high jump, but was unable to collect his trophies.*

## To Be Continued . . .

This book is just the beginning for you. By no means should this be the end of your cartooning education!

Stay curious. Keep reading more and more cartoons. Keep looking for new and exciting books about cartooning and drawing and color and humor writing. You're entering an extremely competitive and demanding field and you're going to need every advantage you can get!

Continue to explore your own creativity. Keep experimenting to find new and better ways to increase your creative energy, be more productive and have more success. Don't allow yourself to become satisfied and complacent.

Continue to develop and perfect your own personal cartooning style. Don't limit yourself, keep exploring different tools and techniques. Try to keep grow-

*Cat grammar.*

ing and changing and improving your style.

Find role models and mentors. Write to your favorite cartoonists and ask specific questions of them. Learn from their experience if you can. Find books and articles about successful cartoonists in your local library, find out what made them successful, and see if you can apply this knowledge to your own career path.

Don't forget that cartooning is a *business*. Read books that can help you become a better businessperson. Listen to motivation tapes that can help you achieve more in your career. Read books that can help you learn about the psychology and strategies of success and personal performance. No matter what business you're in, you can learn valuable success strategies from personal-development authors and lecturers such as Anthony Robbins, Zig Ziglar, Jim Rohn, Denis Waitley and Napoleon Hill. Two of the most popular new books of this genre are *Unlimited Power* and *Awaken The Giant Within* by Anthony

Robbins. Many authors have made their books available on audio tapes which can easily be listened to while you're drawing. These books and tapes may not help you draw better or write funnier, but they can help you to maximize your potential and develop a more outstanding cartooning career.

Remember to set effective goals for yourself. Establish goals that will motivate you and keep you excited about your cartooning future. After you've achieved one goal, create a new one that will take you to your next level of success.

Most important, keep hanging in there! Discouragement and rejection are a fact of life for beginners as well as established professionals. Those who succeed learn to see past temporary setbacks and are able to envision a brighter and more triumphant future.

Yes, successful cartooning requires a lot of hard work, but it can also be a lot of fun . . . so enjoy youself!

Good luck!

# Bibliography

**A Few Recommended Books and Publications**

### Humor and Cartoon Markets

Writer's Digest Books, F&W Publications
1507 Dana Ave., Cincinnati, OH 45207

*This book contains hundreds of names and addresses of places to sell your cartoons and humorous illustrations!*

### Artist's Market

Writer's Digest Books, F&W Publications
1507 Dana Ave., Cincinnati, OH 45207

*More places to sell your work!*

### Getting Started as a Freelance Illustrator or Designer

by Michael Fleishman
North Light Books, F&W Publications
1507 Dana Ave., Cincinnati, OH 45207

*Excellent book for any cartoonist who wants to branch off into humorous illustration. Detailed information on self-promotion, recordkeeping, marketing and more. Highly recommended!*

### How to Be Funny

by Steve Allen
McGraw-Hill Book Co.
1221 Ave. of the Americas
New York, NY 10020

*A scholarly and practical lesson in creating humor for any occasion or format. Almost 300 pages of valuable advice and insight from this legendary comedian, songwriter and author.*

### Comedy Writing Secrets

by Melvin Helitzer
Writer's Digest Books, F&W Publications
1507 Dana Ave., Cincinnati, OH 45207

*More tips on how to be funny!*

### The Art of Humorous Illustration

by Nick Meglin
Watson-Guptill Publications
1515 Broadway
New York, NY 10036

*An insightful look at the work and careers of twelve very successful cartoonists and humorous illustrators, including Johnny Hart, Paul Coker, Jack Davis, Mort Drucker, Arnold Roth, Maurice Sendak and Sergio Aragones.*

### Backstage at the Strips

by Mort Walker
Mason/Charter Publishers
641 Lexington Ave.
New York, NY 10022

*The hugely successful creator of "Beetle Bailey" and "Hi and Lois" gives readers a backstage pass to the world of syndicated comic strips and their creators. Packed with funny anecdotes, illustrations and rare memorabilia!*

### The Big Book of New American Humor (The Best of the Past 25 Years)

Edited by William Novak and Moshe Waldoks
HarperCollins Publishers
10 East 53rd St.
New York, NY 10022

*An enormous collection of contemporary comedy and humor, including samples from gag cartoons, television scripts, Mad magazine, the New Yorker, stand-up comedians, essays, books, and comic strips. Contains work by some great cartoonists, including Tom Cheney, John Caldwell, Sam Gross, Jules Feiffer, Gary Larson, George Booth, Leo Cullum, Mort Drucker, B. Kliban, Lee Lorenz, Don Martin and many, many more!*

### Cartoonist Profiles

281 Bayberry Lane
Westport, CT 06880

*Highly respected quarterly publication full of articles on vintage cartoons, the business of cartooning, publishers, etc.*

### The Gag Re-Cap

Box 774
Bensalem, PA 19020

*As discussed elsewhere in this book, Gag Re-Cap is the easiest way to keep track of what several magazines are buying from cartoonists every month. If you're going to do magazine cartoons, this publication is essential!*

# Permissions

# Index

# Improve your skills, learn a new technique, with these additional books from North Light

Artist's Market: Where & How to Sell Your Art (Annual Directory) $22.95

## Graphics/Business of Art

**Airbrush Action**, by The Editors of Airbrush Action and Rockport Publishers $29.95 (paper)

**Airbrush Artist's Library (2 books)**, $5.95/each

**Airbrushing the Human Form**, by Andy Charlesworth $9.95

**Artist's Friendly Legal Guide**, by Floyd Conner, Peter Karlan, Jean Perwin & David M. Spatt $18.95 (paper)

**Basic Desktop Design & Layout**, by Collier & Cotton $27.95

**Basic Graphic Design & Paste-Up**, by Jack Warren $14.95 (paper)

**Best of Colored Pencil**, Rockport Book $24.95

**Business & Legal Forms for Graphic Designers**, by Tad Crawford $19.95 (paper)

**Business and Legal Forms for Illustrators**, by Tad Crawford $5.95 (paper)

**Business Card Graphics**, from the editors of PIE Books, $34.95 (paper)

**Clip Art Series: Holidays, Animals, Food & Drink, People Doing Sports, Men, Women**, $6.95/each (paper)

**Clip Art Series: Abstract & Geometric Patterns, Graphic Textures & Patterns, Graphic Borders, Spot Illustrations, Christmas, Christmas Graphics**, $6.95/each (paper)

**COLORWORKS: The Designer's Ultimate Guide to Working with Color**, by Dale Russell (5 in series) $9.95 each

**Color Harmony: A Guide to Creative Color Combinations**, by Hideaki Chijiiwa $15.95 (paper)

**Color on Color**, $34.95

**Complete Airbrush & Photoretouching Manual**, by Peter Owen & John Sutcliffe $24.95

**The Complete Book of Caricature**, by Bob Staake $18.95

**The Complete Guide to Greeting Card Design & Illustration**, by Eva Szela $29.95

**Computer Graphics: An International Design Portfolio**, by The Editors of Rockport Publishers $27.95 (paper)

**Creating Dynamic Roughs**, by Alan Swann $12.95

**Creative Self-Promotion on a Limited Budget**, by Sally Prince Davis $19.95 (paper)

**The Creative Stroke**, by Richard Emery $39.95

**Creative Typography**, by Marion March $9.95

**The Designer's Commonsense Business Book**, by Barbara Ganim $22.95 (paper)

**The Designer's Guide to Creating Corporate ID Systems**, by Rose DeNeve $27.95

**The Designer's Guide to Making Money with Your Desktop Computer**, by Jack Neff $19.95 (paper)

**Designing with Color**, by Roy Osborne $26.95

**Desktop Publisher's Easy Type Guide**, by Don Dewsnap $19.95 (paper)

**Dynamic Airbrush**, by David Miller & James Effler $29.95

**Easy Type Guide for Sign Design**, by Don Dewsnap $16.95 (paper)

**59 More Studio Secrets**, by Susan Davis $12.95

**47 Printing Headaches (and How To Avoid Them)**, by Linda S. Sanders $24.95 (paper)

**Fresh Ideas In Letterhead and Business Card Design**, by Diana Martin & Mary Cropper $29.95

**Getting It Printed**, by Beach, Shepro & Russon $29.50 (paper)

**Getting Started as a Freelance Illustrator or Designer**, by Michael Fleischman $16.95 (paper)

**Getting Started in Computer Graphics (Revised)**, by Gary Olsen $27.95 (paper)

**Getting the Max from Your Graphics Computer**, by Lisa Walker & Steve Blount $27.95 (paper)

**Graphically Speaking**, by Mark Beach $29.50 (paper)

**The Graphic Artist's Guide to Marketing & Self-Promotion**, by Sally Prince Davis $19.95 (paper)

**Graphic Artist's Guild Directory of Illustration Vol. 9**, $39.95

**The Graphic Designer's Basic Guide to the Macintosh**, by Meyerowitz and Sanchez $19.95 (paper)

**Graphic Idea Notebook**, by Jan V. White $19.95 (paper)

**Graphics Handbook**, by Howard Munce $14.95 (paper)

**Great Design Using 1, 2 & 3 Colors**, by Supon Design Group $39.95

**Great Type & Lettering Designs**, by David Brier $34.95

**Handbook of Pricing & Ethical Guidelines**, 7th edition, by The Graphic Artist's Guild $22.95 (paper)

**How'd They Design & Print That?**, $26.95

**How to Check and Correct Color Proofs**, by David Bann $27.95

**How to Design Trademarks & Logos**, by Murphy & Row $19.95 (paper)

**How to Draw & Sell Comic Strips**, by Alan

McKenzie $19.95

**How to Draw Charts & Diagrams**, by Bruce Robertson $12.50

**How to Find and Work with an Illustrator**, by Martin Colyer $8.95

**How to Get Great Type Out of Your Computer**, by James Felici $22.95 (paper)

**How to Make Money with Your Airbrush**, by Joseph Sanchez $18.95 (paper)

**How to Make Your Design Business Profitable**, by Joyce Stewart $21.95 (paper)

**How to Understand & Use Design & Layout**, by Alan Swann $21.95 (paper)

**How to Understand & Use Grids**, by Alan Swann $12.95

**How to Write and Illustrate Children's Books**, edited by Treld Pelkey Bicknell and Felicity Trotman, $22.50

**Legal Guide for the Visual Artist**, Revised Edition by Tad Crawford $7.50 (paper)

**Licensing Art & Design**, by Caryn Leland $12.95 (paper)

**Make It Legal**, by Lee Wilson $18.95 (paper)

**Making a Good Layout**, by Lori Siebert & Lisa Ballard $24.95

**Making Your Computer a Design & Business Partner**, by Walker and Blount $10.95 (paper)

**Marker Techniques Workbooks**, (7 in series) $4.95 each

**Newsletter Sourcebook**, by Mark Beach $26.95 (paper)

**Papers for Printing**, by Mark Beach & Ken Russon $39.50 (paper)

**Preparing Your Design for Print**, by Lynn John $12.50

**Presentation Techniques for the Graphic Artist**, by Jenny Mulherin $9.95

**Primo Angeli: Designs for Marketing**, $7.95 (paper)

**Print Production Handbook**, by David Bann $16.95

**The Professional Designer's Guide to Marketing Your Work**, by Mary Yeung $10.50

**Starting Your Small Graphic Design Studio**, by Michael Fleishman $21.95 (paper)

**Type & Color: A Handbook of Creative Combinations**, by Cook and Fleury $39.95

**Type: Design, Color, Character & Use**, by Michael Beaumont $19.95 (paper)

**Type in Place**, by Richard Emery $34.95

**Type Recipes**, by Gregory Wolfe $19.95 (paper)

**Typewise**, written & designed by Kit Hinrichs with Delphine Hirasuna $39.95

**Typography Now: The Next Wave**, $49.95

**The Ultimate Portfolio**, by Martha Metzdorf $32.95

**Using Type Right**, by Philip Brady $18.95 (paper)

## Mixed Media

**The Art of Scratchboard**, by Cecile Curtis $10.95

**The Artist's Complete Health & Safety Guide**, by Monona Rossol $16.95 (paper)

**The Artist's Guide to Using Color**, by Wendon Blake $27.95

**Basic Drawing Techniques**, edited by Greg Albert & Rachel Wolf $14.95 (paper)

**Basic Landscape Techniques**, edited by Greg Albert & Rachel Wolf $16.95

**Basic Oil Painting Techniques**, edited by Greg Albert & Rachel Wolf $16.95 (paper)

**Being an Artist**, by Lew Lehrman $29.95

**Blue and Yellow Don't Make Green**, by Michael Wilcox $24.95

**Bringing Textures to Life**, by Joseph Sheppard $19.95 (paper)

**Bodyworks: A Visual Guide to Drawing the Figure**, by Marbury Hill Brown $10.95

**Business & Legal Forms for Fine Artists**, by Tad Crawford $4.95 (paper)

**Calligraphy Workbooks**, (2-4) $3.95 each

**Capturing Light & Color with Pastel**, by Doug Dawson $27.95

**Colored Pencil Drawing Techniques**, by Iain Hutton-Jamieson $24.95

**The Complete Acrylic Painting Book**, by Wendon Blake $29.95

**The Complete Book of Silk Painting**, by Diane Tuckman & Jan Janas $24.95

**The Complete Colored Pencil Book**, by Bernard Poulin $27.95

**The Complete Guide to Screenprinting**, by Brad Faine $24.95

**Tony Couch's Keys to Successful Painting**, by Tony Couch $27.95

**Complete Guide to Fashion Illustration**, by Colin Barnes $11.95

**The Creative Artist**, by Nita Leland $21.95 (paper)

**Creative Painting with Pastel**, by Carole Katchen $27.95

**Drawing & Painting Animals**, by Cecile Curtis $26.95

**Drawing For Pleasure**, edited by Peter D. Johnson $16.95 (paper)

**Drawing: You Can Do It**, by Greg Albert $24.95

**Exploring Color**, by Nita Leland $24.95 (paper)

**The Figure**, edited by Walt Reed $16.95 (paper)